POSTCARD HISTORY SERIES

South Carolina Postcards

VOLUME X
SUMTER COUNTY

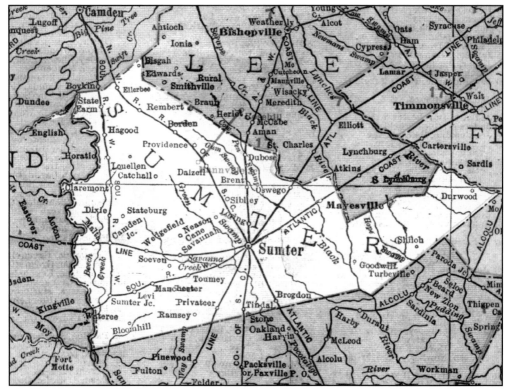

SUMTER MAP, 1910. This 1910 map of South Carolina shows the county boundary lines, the paths of the railroads, and the sites of towns and small communities. Included with the map were lists showing the populations of all localities per the 1910 census. These population numbers are used in the text. Sumter County is highlighted, and parts of the adjacent counties are included.

POSTCARD HISTORY SERIES

South Carolina Postcards

Volume X
Sumter County

Howard Woody and Allan D. Thigpen

ARCADIA

Published by Arcadia Publishing
Charleston SC, Chicago IL, Portsmouth NH, San Francisco CA

Printed in Great Britain

Library of Congress Catalog Card Number: 2005902652

For all general information contact Arcadia Publishing at:
Telephone 843-853-2070
Fax 843-853-0044
E-mail sales@arcadiapublishing.com
For customer service and orders:
Toll-Free 1-888-313-2665

Visit us on the internet at http://www.arcadiapublishing.com

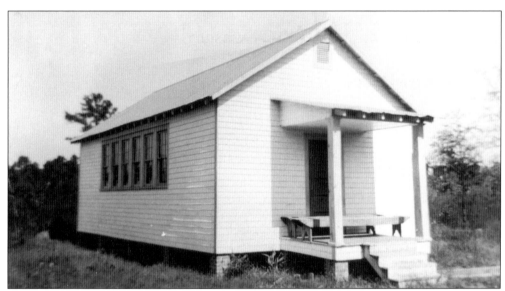

HIAWATHA COLORED SCHOOL, STATEBURG, DISTRICT #10. After the Constitution of 1895 established the concept of "equal but separate schools," some state money was provided to the black schools. In 1912 Sumter County had a dual school system. The white division had 50 school buildings valued at $110,580. There were 38 one-teacher schools, 9 two-teacher schools, 3 three-teacher schools, and 3 more-than-three-teacher schools for 748 pupils. The black division had 57 school buildings that were valued at $10,600. There were 63 one-teacher schools, 5 two-teacher schools, 1 three-teacher school, and 4 more-than-three-teacher schools for 2,788 pupils. The one-teacher school above had 40 black students in a 57-day session in 1913. This frame schoolhouse is similar to many of the early rural buildings.

CONTENTS

INTRODUCTION

The search for historical images that reflect the evolving culture of each South Carolina county at the beginning of the 20th century continues with Sumter County, volume 10. This series began with related multi-county volumes that used the images on early postcards. Volume one covered the Charleston area; Beaufort and the Lowcountry was volume two; Aiken and the West Central section was volume three. Single-area books began in the Midlands with Lexington County, volume four; Richland County, volume five; Newberry County, volume six; Kershaw County, volume seven; and then volume eight, Camden images. After Anderson County, volume nine, the search returned to the Midlands area and Sumter County. The rural images are in volume 10 and the Sumter city pictures may be placed in a future volume.

Sumter County lies between the flood plain of the Wateree River on the west and that of the Lynches River on the east. It lies at the northern edge of the coastal plain. The western portion includes the "High Hills of the Santee," with elevations up to 300 feet. The eastern portion consists of rolling land with a number of swamps that make east-west travel difficult. The Santee, Wateree, and Catawba American Indians used this land for hunting and farming.

The Yamassee War in 1715, between the united American Indian tribes and the winning Europeans, opened the interior to further settlement. In 1734 the South Carolina House of Commons created townships in an effort to encourage settlement of the "back country," which was defined as land more than 50 miles inland from the coast. In 1757 St. Mark's Parish was established northwest of Williamsburg Township and included the land between the Wateree and the Pee Dee Rivers and extended to the North Carolina line.

Sumter County's earliest settlers arrived in the area via the King's Highway, from Charleston across the Santee River to the eastern side of the Wateree River and north to Camden. Wealthy planters and merchants sought relief from the malarial swamps around Charleston in the High Hills. The other route was up the Black River from Georgetown to Kingstree and then to Salem, then north along Lynches Creek. Scotch-Irish farmers with small land grants and merchants and planters from Georgetown followed this route.

Following the French and Indian War, a major migration of immigrants moved south along the Great Wagon Road that extended from Pennsylvania to South Carolina. Between 1765 and 1773 the white population of South Carolina doubled, and by 1790 it had doubled again to over 140,000, most of it in the back country.

During the Revolutionary War only minor skirmishes were fought in the Sumter County area. The British used the King's Highway to supply its forces. Gen. Thomas Sumter and Gen. Francis "Swamp Fox" Marion used the swamps along the Wateree, Black, and Lynches Rivers as bases for their guerrilla operations. Following the Revolutionary War, Thomas Sumter and other landowners bought up as much land as they could or were granted land for Revolutionary War service. Rice production was started in the Wateree valley.

The South Carolina Constitution of 1790 created counties with magistrate and probate courts for improved justice. Claremont, Clarendon, and Salem were three of the new counties. In 1800 the state was reorganized into judicial districts, and these three counties were combined into Sumter District, with a central courthouse to be built in Sumterville. In 1855 Clarendon District was established. In 1868 the remainder of Sumter District was renamed Sumter County. In 1902 Lee County was created and included much of Sumter County's northern area between Lynchburg and Bishopville. Finally, a small portion of Clarendon County, including the town of Pinewood, was annexed to Sumter County in 1922.

Originally Sumter District consisted of 1,672 square miles; Sumter County now encompasses 690 square miles.

With the invention of the cotton gin in 1795, wheat farming quickly shifted to the cultivation of cotton, which, like rice and indigo, required large numbers of slaves for economic production. As cotton production increased, Manchester became a major shipping point on the Wateree River. Goods went by steamship or by barge through the Santee Canal to Charleston. The market price of cotton determined the economic climate of Sumter County. The census of 1860 reported that Sumter County had the highest per capita wealth (excluding slaves) of any county in the state.

In 1848 the railroad came to Sumter when a trestle was completed across the Wateree that connected Manchester to Charleston and Columbia. In 1854 the Wilmington and Manchester Railroad connected Sumterville to that line and also to eastern towns. Union general Edward Potter destroyed these railroads in 1865, but by 1871 new railroads connected Sumter east and west. In the 1890s north and south railroads were built that made Sumter a hub for rail transportation.

Following the Civil War, the county struggled to adjust to the changes in the economy caused by the freeing of the slaves. One of the results of the war was that many former slaves chose to leave the churches of their former owners and form their own congregations. Northern denominations sent missionaries to help organize these churches and to assist the freedmen establish schools for their children. A system of sharecropping emerged over the years, and some blacks became major landowners in their own right.

Logging of the virgin timber in the many swamps became economically feasible. Small sawmill operations began and then quickly grew as capital flowed in to finance the construction of logging railroads. Sumterville changed its name to Sumter and soon became home to a number of woodworking and furniture manufacturing firms. Railroads connected Sumter to Camden via Dalzell and Providence, to Bishopville via Oswego, and from there to Bennettsville. Sumter became a rail hub for up to eight railroads operating east of the Wateree. In 1908, 45 passenger trains stopped daily in Sumter.

In 1925 Sumter County agreed to borrow up to $4 million to provide a system of paved roads. These roads radiated out from the town of Sumter, which attracted rural customers and caused small depot towns to die. These roads and the economic depression of the 1930s had a significant impact on Sumter County. Banks and small businesses failed and farm loans were foreclosed. But some, like the Palmetto Pigeon Plant, prospered even during the poor times. Good roads encouraged merchants to move to Sumter, thereby causing the small towns to die.

This volume, like it predecessors, documents the pre-1890s up through the 1930s. Although the development at Shaw Air Force Base does not technically occur within that time frame, the base is a significant part of Sumter County; therefore, we are including the first 30 years of the base in this historical volume. In 1941 the Army agreed to establish a pilot-training operation on land west of Sumter, and the base was born. By the fall of 1942 over 5,000 military and civilians were employed by the base. The base recently celebrated it 50th anniversary with suitable ceremonies.

The pictures in this book came from postcards, photographs, newspapers, and other sources. As the lead author of the first nine volumes, I want to thank coauthor Allan Thigpen, for the use of numerous images, and the members of the historical societies in Sumter County for the use of their pictures. Both of us thank Chuck Gibbs, Dorothy Reynolds, Geraldine F. "Jay" Ingersoll, Carrie Lenoir, Hugh McLaurin, Dr. Earle Goodman, and many others for their efforts in helping to prepare this volume for publication. It is our hope that the images and captions contained in this volume will reflect the life, times, and culture of Sumter County and its evolution from pre-1900s through the Great Depression.

—Howard Woody and Allan Thigpen

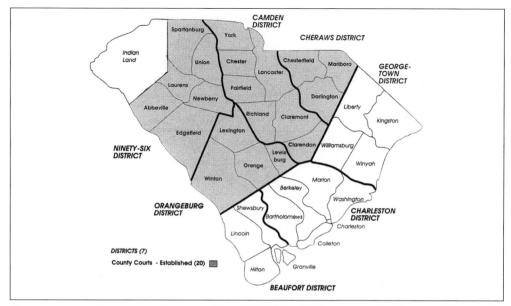

CLAREMONT AND CLARENDON COUNTIES MAP, 1785. The 1785 act gave the Cheraws District the counties of Chesterfield, Marlboro, and Darlington; it divided Camden District into York, Chester, Fairfield, Lancaster, Richland, Claremont, and Clarendon Counties. It gave Ninety-six District the counties of Spartanburg, Union, Laurens, Newberry, Abbeville, and Edgefield. And it divided Orangeburg District into Orange, Lewisburg, Lexington, and Winton (an early version of Barnwell) Counties.

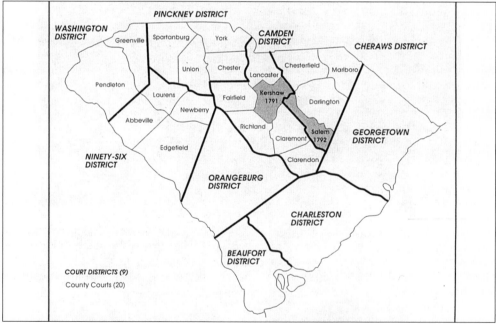

CLAREMONT, CLARENDON, AND SALEM MAP, 1791–1799. In 1791 Salem County was formed from portions of Claremont and Clarendon Counties, and Kershaw County was formed from portions of Claremont, Lancaster, Fairfield, and Richland Counties.

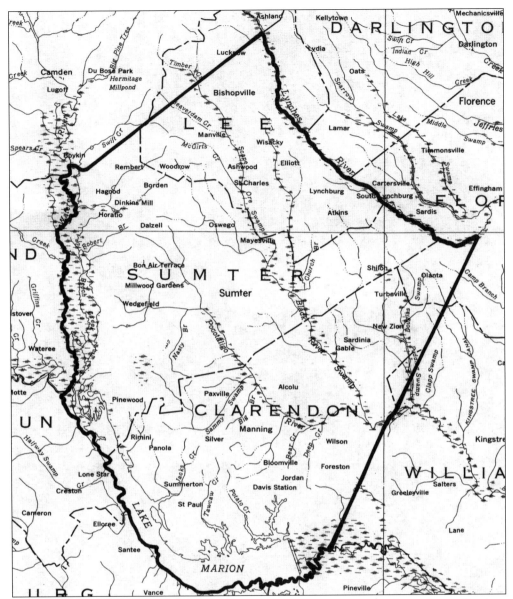

SUMTER DISTRICT MAP, 1800. In 1800 most of the counties were transformed into districts. Washington, Pinckney, Ninety-six, Camden, and Cheraw Districts vanished, and the counties they had encompassed became districts. Claremont, Clarendon, and Salem Counties became Sumter District. Marion District was formed from part of Georgetown, Colleton District from part of Charleston, and Barnwell District from part of Orangeburg. Georgetown yielded Horry District in 1804. That same year, Lexington District was formed from Orangeburg with roughly the same territory as the old county of the same name.

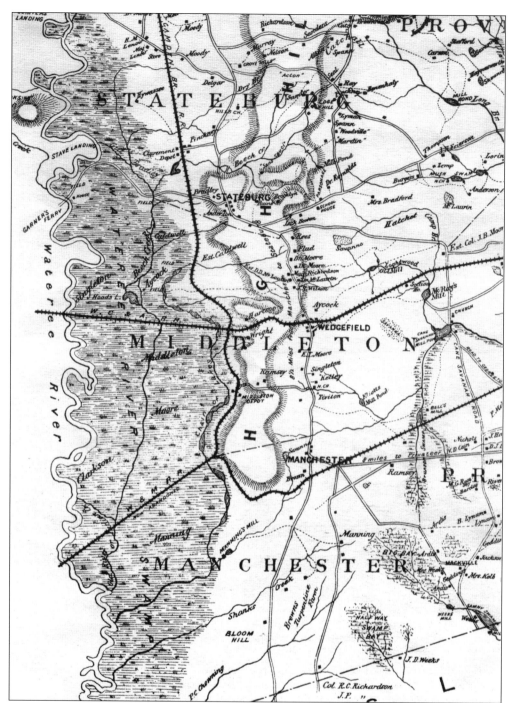

WESTERN SECTION, SUMTER MAP, 1878. This section shows the Wateree River swamps and the Stateburg (60), Middleton (75), and Manchester (59) Townships and their square miles. The railroad paths are indicated, and significant homes and sites marked. Manchester, the bygone 1850s town, is shown with its abandoned railroad bed and destroyed river trestle. Wedgefield, the new rail rub, is indicated, and the great homes of this region are marked.

One

STATEBURG TO PINEWOOD

The Stateburg section is the oldest of the townships that made up Sumter County. The King's Highway that connected Charleston to Camden ran through the district during Colonial times. General Sumter touted Stateburg as a site for the new inland state capital. Columbia won by one vote.

As the cultivation of cotton spread, large plantations developed along the Wateree River. The center of economic activity shifted south to Manchester, which had access to the river and became a shipping point for goods.

In 1871 a new railroad bridge was built across the Wateree River, and the town of Wedgefield rapidly grew up around the new depot. In 1889 the Manchester and Augusta Railroad opened a new station and named it Pinewood.

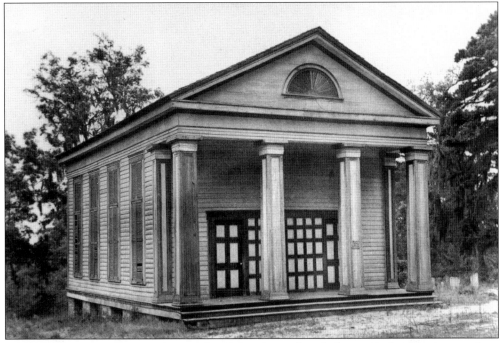

HIGH HILLS BAPTIST CHURCH. This Stateburg church was founded in 1770 after Baptist preachers visited the area. One 16-year-old boy, Richard Furman, was converted. He was ordained there in 1774 and became the pastor. After the Revolutionary War, he preached here until 1787, when he accepted a call to Charleston. At one time, three racial groups attended this church. The Turks sat on the left, the whites on the right, and the blacks in the gallery. This sanctuary was built *c.* 1803. The church is still in use.

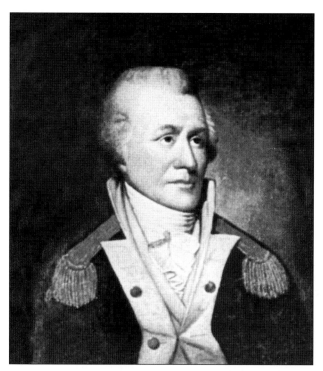

Gen. Thomas Sumter, Portrait. Thomas Sumter (1734–1832) was born in Hanover County, Virginia. He served in the Indian Service on the frontier and was chosen to escort Cherokee warriors to England. He arrived in Charleston in 1762 and later settled in Stateburg. His public services include commandant of the 6th Regiment South Carolina Line, Continental Establishment, 1776–1778; brigadier general of the South Carolina Militia, 1780–1782; member of the Continental Congress, 1783–1784; member of the United States Congress, 1789–1793 and 1797–1801; and United States senator, 1801–1810. Both the county and the city are named for General Sumter.

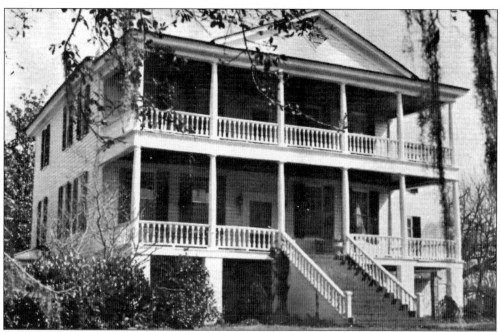

Edgehill Plantation. Edgehill house was built *c.* 1759 and may have been later owned by General Sumter. His granddaughter, Mrs. Louisa Murrell, lived in the house in 1837. The house was called Edgehill Academy and served as a boys' school under schoolmaster Willard Richardson. It has been said that John Rutledge lived there when he was named the first governor of South Carolina following the Revolution. It is located near Shaw Air Force Base.

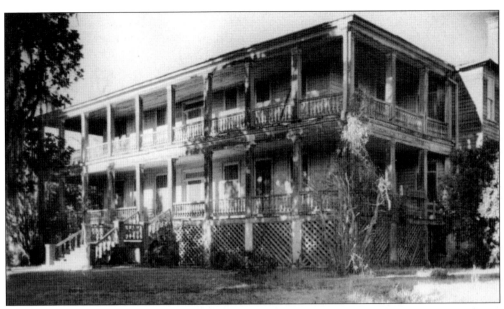

THE RUINS. This home was probably erected in 1780 on a land grant given to Peter Matthews in 1770. Gen. Thomas Sumter obtained the property in 1784 at a cost of £100. John Mayrant Sr. bought the property in 1802; his son sold it to Willis W. Alston, a schoolmaster, in 1835. Alston changed the name to Hawthorndean Seminary for Young Ladies. Robert DeVeaux bought the property in 1837. He and his wife, Marion Singleton, called it The Ruins. Ownership passed to Amelia Noel Moore Barnwell in 1928, and it remained in the Barnwell family until 1996. The house still stands in good repair as of 2004.

NATALIE DELAGE SUMTER (1782– 1841). Natalie DeLage de Volude of France sought safety in the United States during the period of the French Revolution. When the revolutionary trials and executions were over, she was returning to Paris by ship when she met Thomas Sumter Jr., General Sumter's son. They fell in love and married in Paris, France. They returned to the United States and lived in Home House, a gift from General Sumter. She helped establish the first Roman Catholic church in Claremont County.

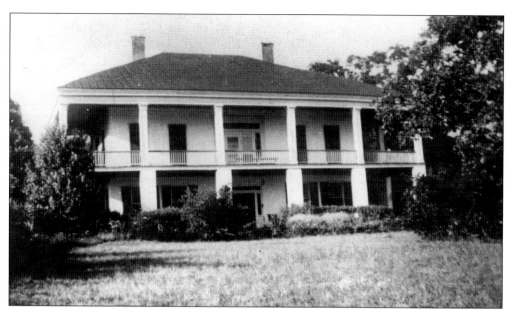

MARSTON HOUSE. This antebellum home and plantation was located in the Stateburg area. Col. Patrick Henry Nelson built the house in the early 1800s. Col. John J. Dargan purchased the home in 1905 and lived in it while he was the superintendent of a nearby school at Acton.

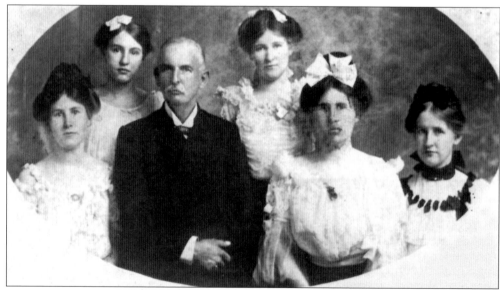

CHIQUOLA CLUB. Col. John J. Dargan and his five daughters, Theodosia, Elizabeth, Sarah, Gena, and Georgia, formed the Chiquola Club. Dargan gave lectures on history and his daughters played musical instruments and sang to entertain the audience on his lecture tours.

WILLIAM MURRELL. William Murrell (1736–1820) was one of the last three magistrates and a judge of probate for Claremont County before it became part of Sumter District in 1800. He and General Sumter were among the founding members of Claremont Episcopal Church, which later became known as Holy Cross Episcopal Church. His son, James W. Murrell, married Louisa, granddaughter of Gen. Thomas Sumter; they lived at Edgehill Plantation. His daughter, Mary Elizabeth Murrell, married John Blount Miller (1782–1851), who served as commissioner of equity for Sumter District from 1817 until 1851.

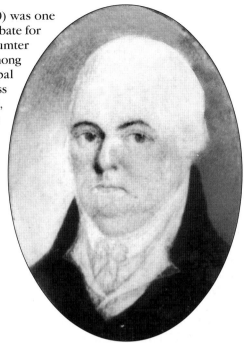

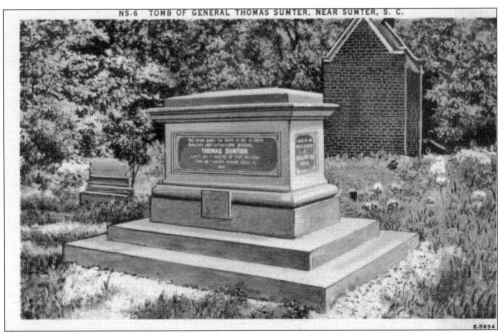

NS-6 TOMB OF GENERAL THOMAS SUMTER, NEAR SUMTER, S. C.

TOMB OF GEN. THOMAS SUMTER AND NATALIE DELAGE'S CHAPEL. General Sumter came to South Carolina in 1762. He was a frontier boy and American Indian fighter. At age 76 he was weary of public service and retired to the High Hills. He died in 1832 at age 98. This monument was erected by an act of the South Carolina General Assembly in 1907. Natalie DeLage's Chapel, in the background, is in the Sumter family burying grounds in the High Hills of the Santee. The chapel was erected over her grave by her children, as requested in her will.

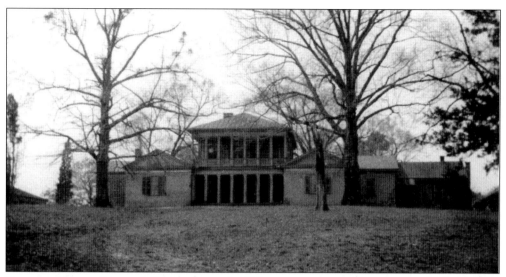

BOROUGH HOUSE. Borough House, formerly Hillcrest, was owned by Adam F. Brisbane, who also owned a tavern along the King's Highway during Colonial times. The oldest part of the house, of frame construction, was built on land granted to William Hilton in 1758. It was the headquarters for General Greene during the Revolutionary War. In 1792 the home was sold to Thomas Hooper, who added two frame wings. These frame wings were replaced in 1821 by Dr. William Wallace Anderson, who substituted *pise de terre* (rammed earth), a construction method of Spanish and French origin. The doctor was a planter and practiced medicine in Stateburg. The house is on the National Register of Historic Places.

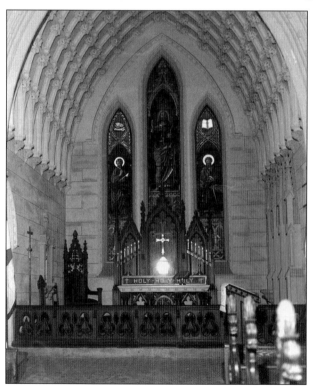

CHURCH OF THE HOLY CROSS, INTERIOR. The interior measurements are 100 feet from the west end of the nave to the east end of the cancel. The nave is 25 feet wide, and the transept is 56 feet long by 25 feet wide. The beautiful stained-glass windows, made in Bavaria, Germany, at a cost of $1,003, are based on designs by Frederich Auerbach. The organ was built by Henry Erben of New York and installed in 1851.

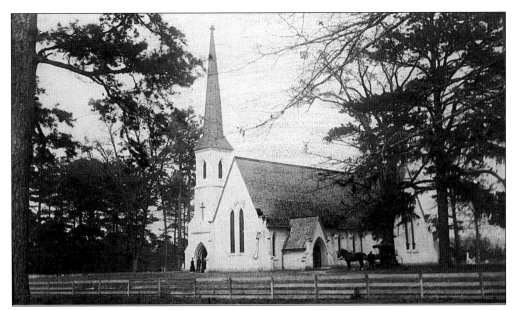

CHURCH OF THE HOLY CROSS, EXTERIOR. The Church of the Holy Cross was built using the *pise de terre* method of construction. It was completed in 1851 at a cost of $11,358.74. This church replaced the original Claremont Episcopal Church, built *c.* 1788 as a chapel of ease. The architect was Edward Jones of Charleston. The Charleston Earthquake of 1886 dislodged the tower from the building, and a tornado in 1903 blew down the steeple. The church is on the National Register of Historic Places.

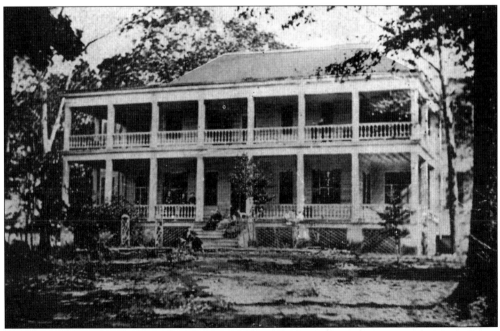

WOODLAWN PLANTATION HOUSE. Mr. Orlando Rees, a successful planter, owned Woodlawn Plantation. It was later owned by William R. Flud. The house burned in May 1891.

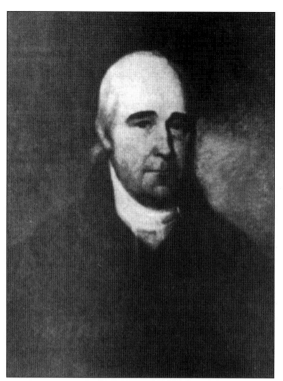

REV. RICHARD FURMAN. Rev. Richard Furman's (1755–1825) family moved to South Carolina in 1770 and settled on a land grant at Stateburg. After Rev. Joseph Reese preached in Stateburg, Furman converted from the Church of England to the Baptist faith and formed the High Hills Baptist Church. He later received a master of arts degree from Rhode Island College and a doctor of divinity degree from the South Carolina College. He began preaching in 1772 and was ordained in 1774. Furman was an outspoken advocate for the patriot's cause during the Revolutionary War. The British placed a price of £1,000 on his head. After the war, he returned to High Hills Baptist Church as pastor and remained there until he accepted a call to preach in Charleston.

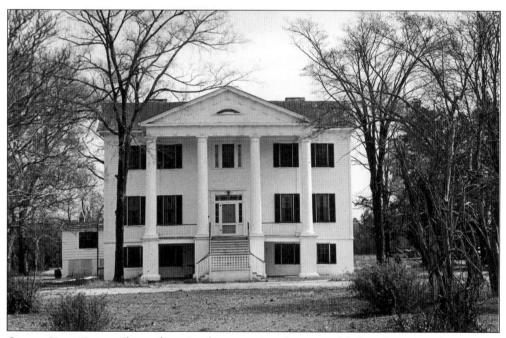

CHERRY VALE, FRONT. Shown here is a large section that was added to the original structure. The site is near Shaw Air Force Base. During the construction of the runways in 1941, the United States Corps of Engineers used Cherry Vale as its office. Later Cherry Vale was used as a club for noncommissioned officers. It burned in the 1950s.

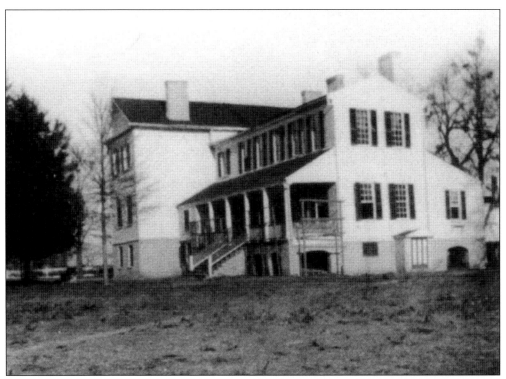

CHERRY VALE, BACK. Cherry Vale was acquired in 1794 by Henry Vaughan II and sold in 1836 by Henry Vaughan III to his brother-in-law, John James Frierson. John N. Frierson married Miss Converse, daughter of an Episcopal minister, and named it Cherry Vale. Frierson served in various capacities with the Democratic Party during Reconstruction. Following the election of Wade Hampton in 1877 as governor, John N. Frierson was appointed jury commissioner for Sumter County.

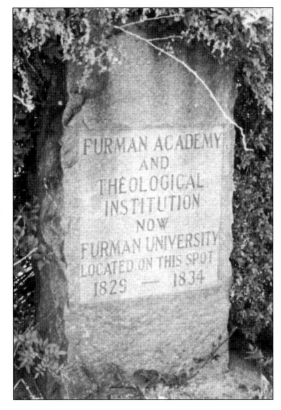

FURMAN ACADEMY MARKER. Rev. Robert M. Roberts, pastor of High Hills Baptist Church, established an academy in Stateburg *c.* 1800; it was funded by the Baptist State Convention to educate ministerial students. After Robert's death, Furman Academy was established in Edgefield. It was soon relocated to the High Hills in 1829, then moved to Fairfield, and finally to Greenville, where it was chartered as Furman University in 1850.

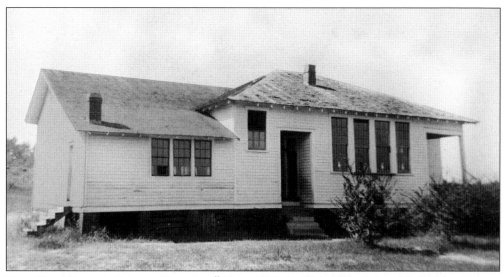

HIGH HILLS COLORED SCHOOL, DISTRICT #11. In 1913 the High Hills Colored School was a one-teacher black school with 72 students and a 60-day school year. In 1925 the initial building was replaced with a Rosenwald school. Rosenwald grants were given to improve the quality of education for rural black students since Southern states gave very little financial support to black education. The fund sponsored 13 schools in Sumter County and 481 schools throughout the state. High Hills Colored School was located just north of Meeting House Road and east of S.C. 261, King's Highway.

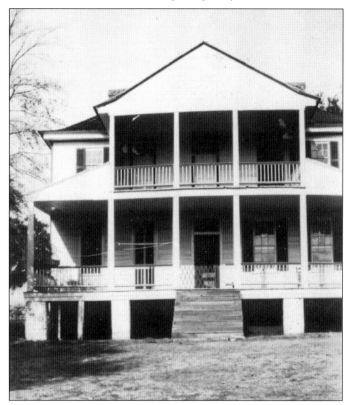

SANS SOUCI HOUSE. This High Hills house was the summer home of Edward Rutledge, signer of the Declaration of Independence, and brothers John Rutledge, governor of South Carolina during the Revolution, and Hugh, a lawyer and member of the Commons House during the Revolutionary War. After 1790 Hugh was appointed to various courts as judge. When he died in 1811 he was referred to as senior judge, South Carolina Court of Equity. The house was destroyed by fire in 1934.

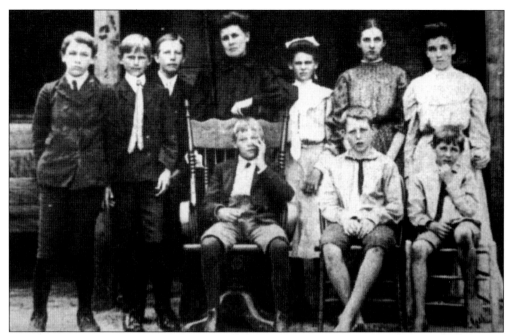

STUDENTS, STATEBURG SCHOOL, DISTRICT #6, 1918. This photograph of students at Stateburg School includes children from the Barnwell, Leavell, Mellette, Moore, Ramsey, and Saunders families. In 1900 Stateburg School District #6 had three white teachers who taught 69 students for a school year of 108 days. J. H. Pinckney was the school superintendent. Standing in the back row behind the chair is the teacher, Anna Burgess. This school was located on Tarleton Road, south of Fish Road.

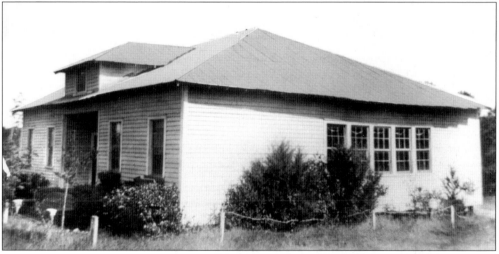

STATEBURG COLORED SCHOOL, DISTRICT #6. In 1900 Stateburg School District #6 had seven black one-teacher schools with 549 students in a session of 96 days. In 1913 this one-teacher school had 130 students in a session of 100 days. This school opened in 1920 as a Rosenwald school. The Rosenwald Fund paid 30 percent of the construction costs, with the remainder paid by local and state sources. It was located on Wayman Chapel A.M.E. Church property north of U.S. 76/378 on S.C. 261, King's Highway.

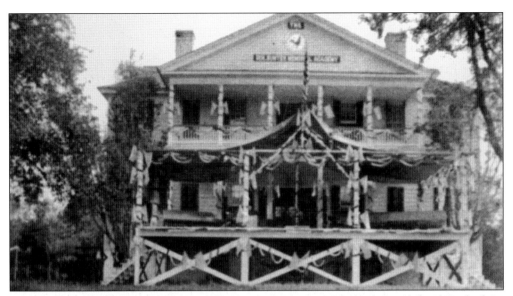

ACTON, GENERAL SUMTER MEMORIAL ACADEMY, 1908. Acton was built by Cleland Kinloch in 1803. Here Acton is shown decorated for ceremonies marking the opening of the school's demonstration farm in 1908. General Sumter Memorial Academy was the first high school in the United States to include this program in its curriculum. Founded in 1905 by Col. John J. Dargan and housed at Acton, the old plantation home of Francis K. Acton, this academy was the first consolidated, rural high school in South Carolina. It served pupils in Sumter School Districts 8, 9, 10, and 11. It was the first rural, public high school to provide transportation to students using two mule-powered covered wagons. Acton burned in 1911.

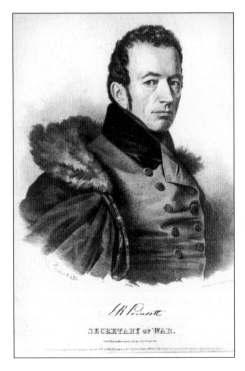

JOEL R. POINSETT. Joel R. Poinsett (1779–1851) was a native of Charleston. He was a statesman, diplomat, author, and naturalist. A friend of Dr. W. W. Anderson interested in botany, Poinsett traveled extensively. While first minister to Mexico *c.* 1824, he discovered a species of flowering euphorbia that he introduced to the United States. It became known as the poinsettia. Poinsett was a state senator, member of Congress, and secretary of war under President Van Buren. He opposed John C. Calhoun on the issue of nullification.

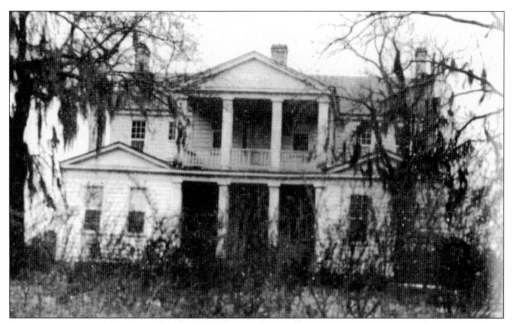

BROOKLAND. Brookland was built *c.* 1804 by Judge William Dobein James, author of *Memoirs of the Life of Brigadier General Francis Marion*. He had served with General Marion during the Revolutionary War. Elected chancellor of the court of equity in 1802, he transferred to the law bench in 1824. He became an alcoholic and was impeached in 1828. Judge James died at Brookland. He bequeathed it to his daughter, Sarah, who sold it to John Bradley in 1836.

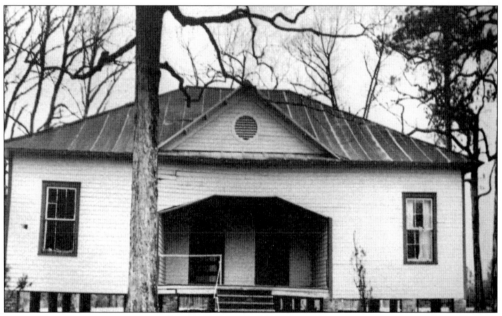

STATEBURG SCHOOL, DISTRICT #10. In 1913 Stateburg School (white) District #10 had one teacher for the 18 students in a 152-day session. Ms. Olive B. Newton was the teacher in 1916. This schoolhouse was built as a replacement for Acton, destroyed by fire in 1911. The students attending this school were transferred to the new Hillcrest High School in 1928.

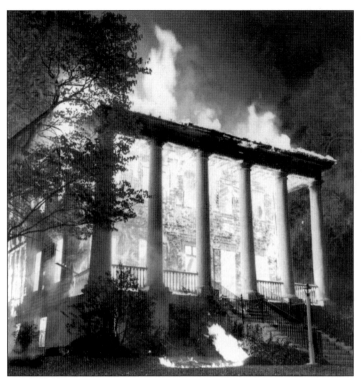

THE OAKS. This beautiful home, located in the High Hills of the Santee, was rebuilt by Dr. W. W. Anderson in 1832 for his relatives, Merry and Jolly Bracy. They named it, The Oaks. Over the years it changed hands several times, until it was bought in 1951 by Alfred C. and Gertrude A. DeLorme. This photo shows it engulfed in flames when it burned in 1965. It has since been rebuilt and is presently occupied by the DeLorme family.

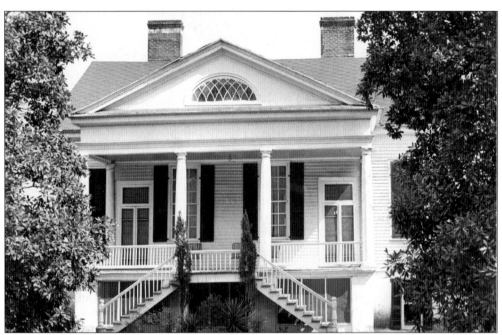

NEEDWOOD HOUSE. The land on which this house was built was called Whiskey Hall by the owner, Robert F. Withers. He sold it to Frederick Wentworth Rees in 1823, who built this antebellum home in 1827. It was originally plastered on the exterior and was located off U.S. 76, near Shaw Air Force Base. It was destroyed by fire in 1987.

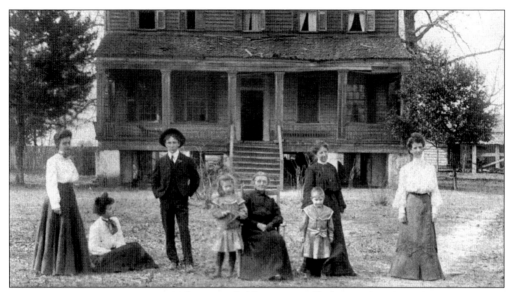

HOMEFIELD, CARSON FAMILY, 1905. Homefield was initially begun by Tyre Jennings *c.* 1829 for his future bride, but it was left unfinished. It was later purchased by Elisha Scott Carson in 1830. It was named by a passing circuit-riding preacher, who had enjoyed Susan Marsh Carson's hospitality. James Marsh Carson married Margaret Smythe Dukes, and they lived at Homefield. Carson family members are shown in the picture above. The house site was at the north end of Shaw Air Force Base runway. This structure burned in the 1980s.

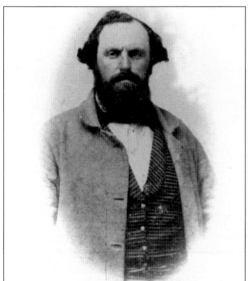
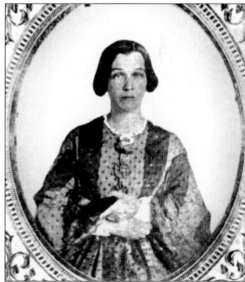

COL. FRANCIS MARION MELLETTE AND ELIZABETH P. R. MELLETTE. Col. Francis Marion Mellette (1822–1893) was a lieutenant colonel in the 4th regiment, South Carolina State Troops of the Confederate Army. His grandfather, John, served in the Revolutionary War, and his father fought with Francis Marion in the Battle of Eutaw Springs in 1782. He married Emma E. A. Cain in 1842, who died in 1853 leaving six children. His eldest son was Peter. In 1854 Francis married Elizabeth Placedia Ramsey (1836–1901), daughter of Willis Allen Ramsey and Elizabeth Odil. She was his second wife and bore four daughters and a son.

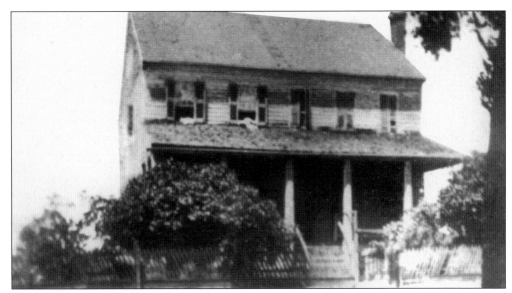

ARGYLE HOUSE. Argyle House was built in 1753. Sherwood James owned the house; he operated a tavern nearby. John Gabriel Guignard bought the home in 1778. The next owner, in 1787, was William Mayrant, United States congressman and pioneer Sumterville businessman, who named it Ararat, meaning "Here I rest." The grounds had served as an encampment for General Greene during the Revolutionary War. Daniel McLaurin bought the house along with 2171 acres in 1857. He renamed it Argyle for his clan's roots in Scotland. The house, which burned in 1920, was located on S.C. 261, King's Highway.

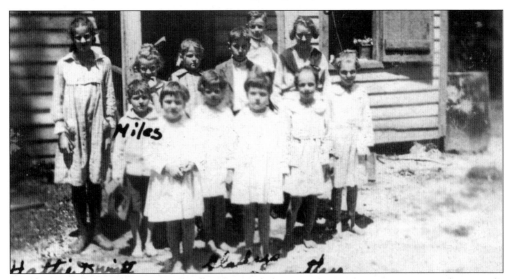

ARGYLE SCHOOL STUDENTS, DISTRICT #21, 1918. In 1900 McLaurin's private one-teacher Argyle School, District #21, had 22 white students in a 36-week session. J. B. Ryan was the teacher. In 1913 the private Argyle School had a school session of 129 days for nine students. The picture above shows the 1918 class. Children of the Dwight, Chandler, Dew, and McLaurin families attended the McLaurin school. Mrs. E. N. Sullivan was the teacher in 1921. Argyle School consolidated with Wedgefield School in 1922. It was located at the intersection of Argyle Drive and S.C. 261, King's Highway.

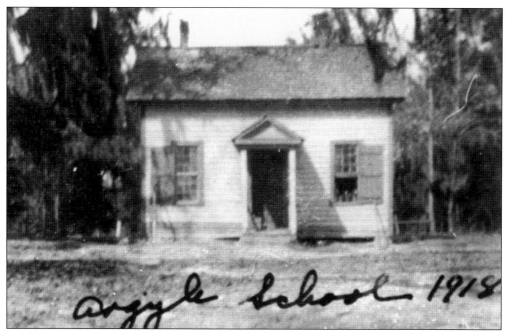

ARGYLE (PRIVATE) SCHOOL, 1918. Mary Agnes McLaurin taught white preschool children in a room in Dr. Henry McLaurin's home, Argyle plantation, in the 1880s. She was followed by Catherine Louisa McLaurin, who first taught in the home and later in a small school that her brothers built in the front yard in 1885. For six months each year Argyle was a public school. Parents paid the school expenses for the other three months. The school was located on McLaurin property at the intersection of Argyle Drive and S.C. 261, King's Highway.

STIRLING. This Greek-Revival home of the McLaurin family was built in 1869. The two-story home was built by Dr. Henry J. McLaurin (1838–1921) and was named Stirling, for Stirling Castle in Scotland, from where the McLaurin family emigrated in 1790. Stirling's fourth generation owners are Brig. Gen. and Mrs. Hugh M. McLaurin III.

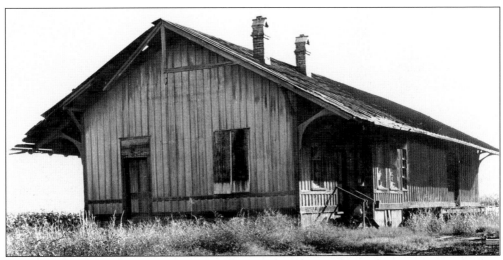

DEPOT, WEDGEFIELD. The Wilmington-Manchester Railroad had its western terminal in Manchester, south of Wedgefield. Manchester, the 10th largest South Carolina town in 1850, had a river landing and had a depot on the branch line that connected Camden to the old South Carolina Railroad at Kingsville in 1848. The Wilmington-Manchester Railroad was abandoned in 1865 after General Potter destroyed the trestle across the Wateree River. The Wilmington, Columbia and Augusta Railroad built a new trestle across the Wateree in 1871. It connected Sumter with Columbia using a new station on Wedgefield Plantation, a few miles north of Manchester. Businesses quickly moved to Wedgefield. The town grew, and the depot became the rail hub for this section of Sumter County. The depot was abandoned in the 1960s.

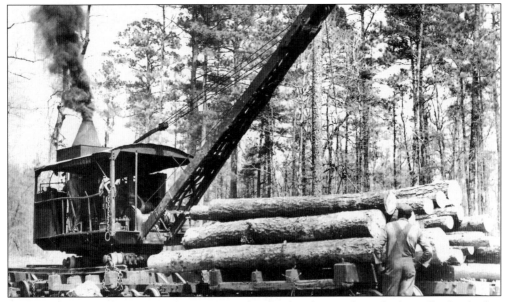

STEAM-POWERED LOG LOADER. The American log loader shown above had small wheels that ran on raised rails. It would lift logs and stack them until the log car was filled, and then it would back up to the next car and repeat the loading process. When all the cars were loaded, an engine would pull the train out of the forest.

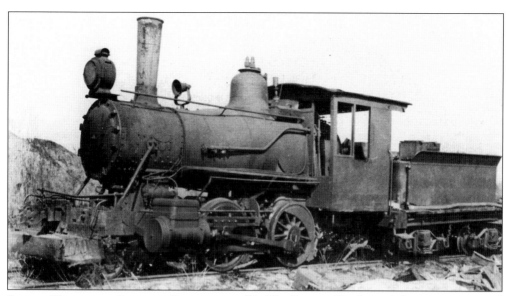

SUMTER HARDWOOD COMPANY, LOCOMOTIVE #1. The Sumter Hardwood Company operated three Climax-geared steam engines, all of which were bought secondhand through Southern Iron and Equipment Company in Atlanta. A small 2-4-0 served as the company's #1 at Stateburg near the Wateree Swamp. A larger 2-6-0 hauled heavier trains as the company's #8. The company processed cypress, gum, and poplar and accumulated a half million feet of timber on their yards.

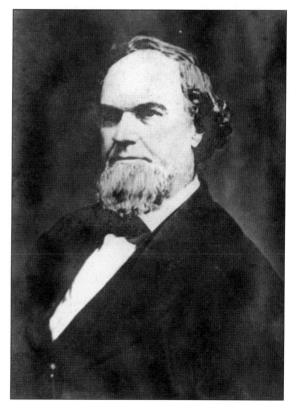

DANIEL BENJAMIN MCLAURIN JR. (1807–1876). Born in McColl (Marlboro County), D. B. McLaurin taught school in the Mayesville area. He attended Mt. Zion Presbyterian Church and married Agnes Drusilla Chandler of that area. He moved to Sumterville, operated a hotel for a time, and served as mayor. He was a promoter of the Wilmington and Manchester Railroad, which was completed in 1854. He moved his family to the vicinity of Manchester and took up his family's Kings grant. He bought Ararat plantation in 1857 and renamed it Argyle after his ancestral home in Scotland.

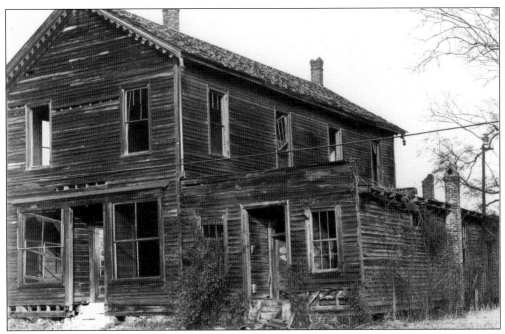

AYCOCK STORE AND THE WEDGEFIELD POST OFFICE. James H. Aycock erected this building in 1879 as the headquarters for his five cotton plantations. Seven clerks lived in the second story. The one-story building on the right was the early post office. The building stood at the intersection of S.C. 261 and S.C. 763.

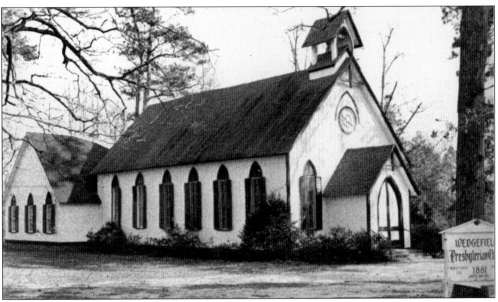

WEDGEFIELD PRESBYTERIAN CHURCH. Wedgefield Presbyterian Church was organized on July 2, 1881, with 12 members. It was built on land donated by James H. Aycock, and its first service was held on July 3, 1881. Rev. H. B. Garris was the first minister from May 1885 to October 1886, and Mr. Cornelius McLaurin was the first Sunday school superintendent. The site is at 4 Presbyterian Road in Wedgefield.

INITIAL WEDGEFIELD SCHOOL, MIDDLETON, DISTRICT #5, c. 1900. In 1900 Middleton School District #5 white division had one private school with two teachers and 80 students and no public schools. A. E. Aycock was the school superintendent. In 1913 W. C. Taylor was principal with 73 students, 3 teachers, and a session of 173 days. Built prior to 1918, this building had four classrooms downstairs, an auditorium upstairs, and a stairway in the center of the building. Bathroom and toilets were located outside. The building was torn down about 1936. The school was located at the intersection of S.C. 261, King's Highway, and Wedgefield Road, S.C. 763.

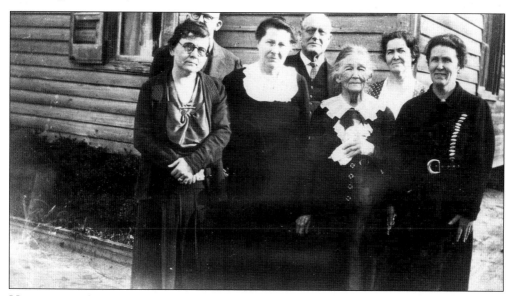

MELLETTE AND CAIN FAMILY REUNION, c. 1931. Descendents of the six children of Francis Marion Mellette and Emma Cain had this reunion at the home of E. W. Nettles in Wedgefield. They are as follows, from left to right: (front row) Floy Betha Cain, Julia Nettles Mellette, Eunice Cain Mellette, and Nan Mellette McMillan; (back row) Frank Cain, E. W. Nettles, and Lucy Mellette Nettles.

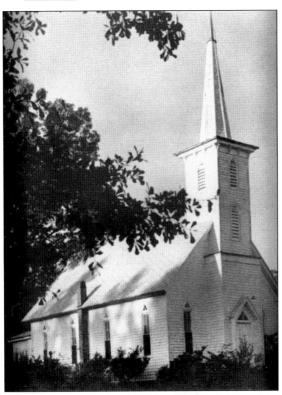

WEDGEFIELD BAPTIST CHURCH. The first gatherings were held at the railroad depot platform and were conducted by Rev. Noah Graham in early 1881. The church was organized that year with 14 charter members, and they began using the old schoolhouse. The sanctuary was finished in 1885 on land donated by James H. Aycock. Peter Mellette, who died in 1908, helped organize the church. He was a deacon and Sunday school superintendent.

WEDGEFIELD SCHOOL, MIDDLETON, DISTRICT #5. Wedgefield School was built by the Works Projects Administration (WPA), from 1938 to 1939. It served white students in grades one through seven in three classrooms. The teachers were Mrs. Lucie Platt, grades one and two; Mrs. Colzy Ryan, grades three, four, and five; and Mrs. Janiebell Guess, grades six and seven. The school was located at the intersection of S.C. 261, King's Highway, and Wedgefield Road, S.C. 761. It is now owned by the Wedgefield Baptist Church and used as a community center.

HENRY JAMES DUNCAN MCLAURIN, M.D. (1838–1921). Dr. McLaurin graduated from Davidson College and the University of Virginia's medical school. He joined the Manning Guards of Hampton's Legion and was promoted to surgeon of the 7th South Carolina Calvary at the Battle of Gettysburg. He married Elizabeth McFaddin. Following the Civil War, he practiced medicine and conducted lumbering operations between Pinewood and Stateburg. This photo was taken in 1870.

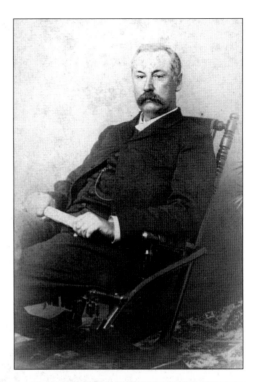

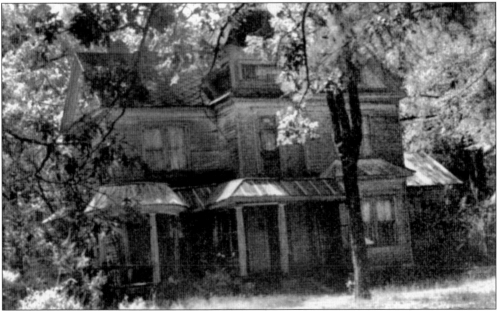

AYCOCK HOME, WEDGEFIELD. Here is one of the homes owned by James H. Aycock, pioneer in the turpentine and cotton industries during the Reconstruction period. He moved from Rockingham, North Carolina, and built a store in Wedgefield in 1879. He also built a sawmill that prepared the lumber for his store. This house was built in 1889. He married twice and had three children by each wife. When he died in 1895, he owned one of the largest cotton plantations in South Carolina.

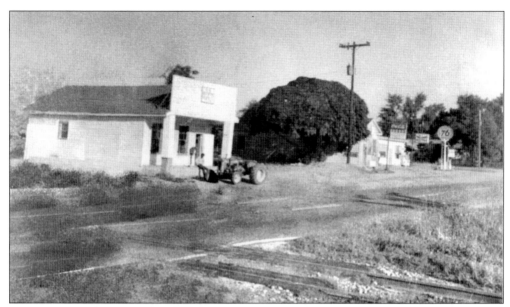

UNITED STATES POST OFFICE AND BATTENS STORE, WEDGEFIELD. This view of the northwest side of S.C. 261 shows the U.S. post office, which was a community center where citizens picked up their mail and exchanged gossip. On the far side of the large tree was Battens Store, which stocked a wide range of groceries and supplies.

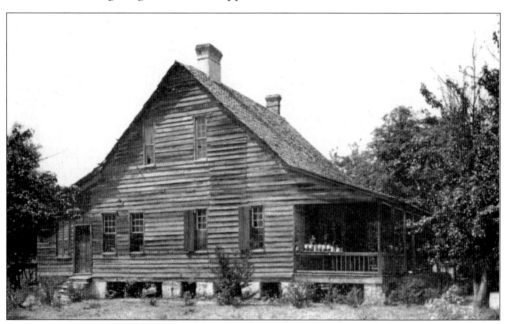

MELROSE HOUSE, POINSETT STATE PARK. Mathew Singleton, a Revolutionary War veteran, built Melrose House, *c.* 1760s, in the Manchester area. It was a small house with a one-story piazza extending across the entire front of the building that shielded two large rooms from the sun. At both gabled ends are large chimneys that are flanked by two long, narrow windows. A stairway in the hall extends to the upper rooms. The house was destroyed by fire in the 1960s.

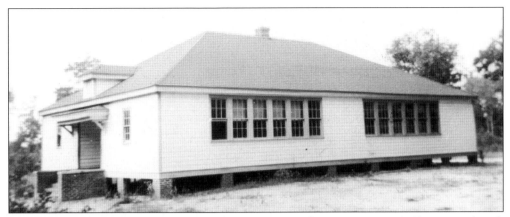

ORANGE HILL COLORED SCHOOL, MIDDLETON, DISTRICT #5. The Orange Hill A.M.E. Church was formed in 1866 when the former slaves left the Wedgefield Methodist Church. This A.M.E. church, like others in Sumter County, began teaching both children and adults in their sanctuary. Later they built a schoolhouse on their grounds. In 1900 the Colored School Division of Middleton School District #5 had a one-teacher public school and two private (church sponsored) schools with a total of 295 students and a session of 36 days. In 1913 this one-teacher school had 140 students in a 75-day session. It was located south of Wedgefield, between Middleton Road and Tiverton Road.

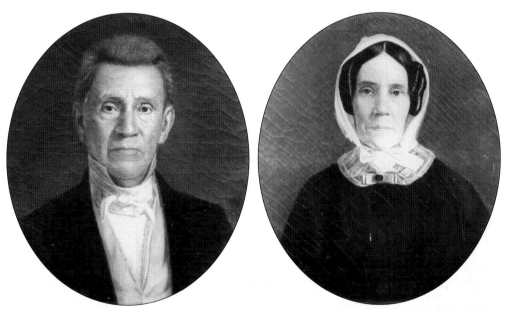

RICHARD SINGLETON AND MRS. REBECCA SINGLETON. Richard Singleton (1776–1852) had a beautiful plantation at Manchester and another one in Richland County. The Singleton family provided freight service to Charleston and Columbia using flatboats propelled by "polemen." A string of loaded flatboats would carry the goods to market; then, the slightly smaller boats would be stacked one inside the next and returned to the Manchester landing. One hundred acres of rice were farmed in the Wateree River swamps, protected by 5-foot-high to 15-foot-high dikes. Singleton died in a train wreck while crossing the Wateree River. Rebecca Travis Coles Singleton (1782–1849), wife of Col. Richard Singleton, was from Virginia. She was the mother of Angelica, daughter-in-law of President Martin Van Buren.

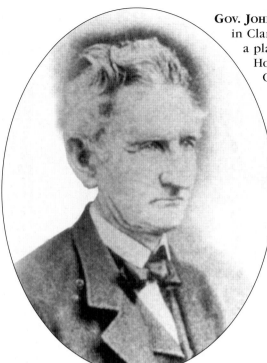

GOV. JOHN P. RICHARDSON III (1831–1899). Born in Clarendon County in 1831, Richardson was a planter who served in the South Carolina House from 1856 to 1861. He then joined the Confederate Army and served under General Cantey, and he later served in the South Carolina House and Senate. In 1880 he was elected treasurer of South Carolina as a Democrat. He served there until he was elected governor in 1886 and reelected in 1888. The family plantation, called Chateau de la Fontaine, was destroyed by fire in 1906. Richardson died in Columbia in 1899.

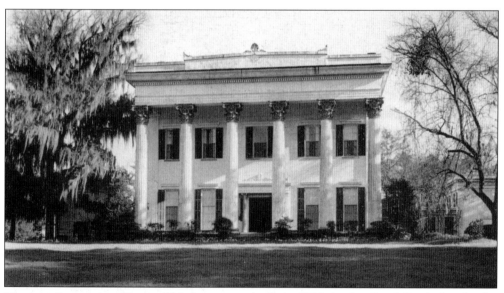

MILFORD PLANTATION HOUSE. This home was built in 1839, in the Greek-Revival style, for Gov. John Laurence Manning by Nathaniel P. Potter, an architect from Rhode Island. It cost $9,600, not including slave labor. It was built of Connecticut granite that was brought by ship to Charleston and then shipped by boat and wagon to the site. The foundation required 300,000 bricks. The exterior walls are stucco-covered brick, two feet thick, with yellow pine framing, both of which were manufactured on-site. There are six carved columns in front. The house has been recently restored.

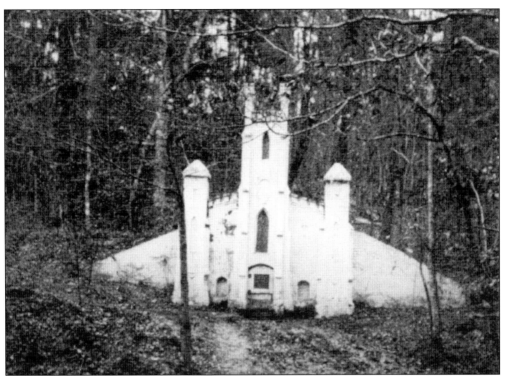

SPRING HOUSE, MILFORD. This structure, with its decorative design, is located on Milford Plantation. It is said to be a miniature version of Trinity Episcopal Church in Columbia, where the Mannings, builders of Milford, are buried. It is built over a spring that produces delicious water, which is said to give new meaning to "bourbon and branch water." The house has been restored.

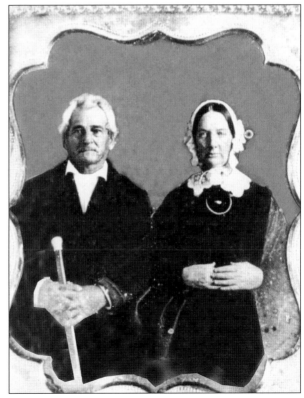

JOHN NETTLES AND DAUGHTER, HARRIET REBECCA NETTLES. John Nettles (1790–1863) married Elizabeth John Miller, daughter of John Blount Miller. Their daughter, Harriet Rebecca Nettles (1839-1876), never married.

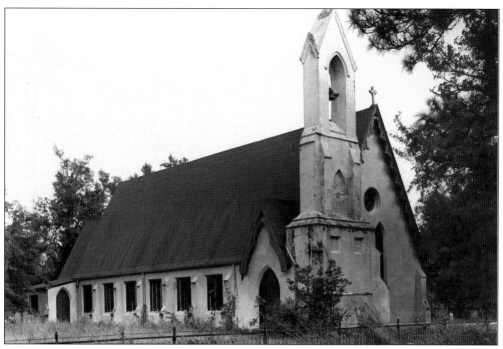

St. Mark's Church, Pinewood. St. Mark's Parish was created in 1757. In 1764 Richard Richardson donated 150 acres. The initial St. Marks edifice was built in 1765, and a four-room frame house was erected as a rectory in 1767. Charles Woodmason became the first rector in 1770. After the British burned the church during the Revolutionary War, a new church was built in 1830 away from the swamp and near the present site. A forest fire destroyed that church in 1850. The present St. Marks Church is the third sanctuary for this community. Designed by Edward C. Jones, it was built *c.* 1853.

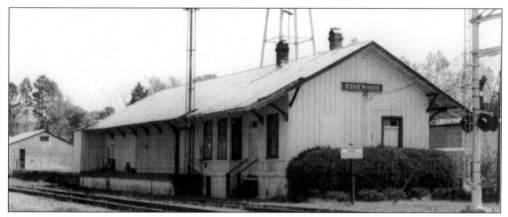

Pinewood Depot, Atlantic Coast Line Railroad. On April 29, 1889, the Augusta and Manchester Railroad dedicated a new depot and named it Pinewood. When the town was incorporated in 1899, there was an effort to change the name, but the railroad refused. Lumber, cotton, and other agricultural products were shipped from the depot, the last product being fullers earth, which was used as kitty litter. At one time 85 trains ran through Pinewood daily. The town agreed to be annexed by Sumter County in 1921. The exterior of the depot was renovated in 2002, and it is the last depot still standing in Sumter County.

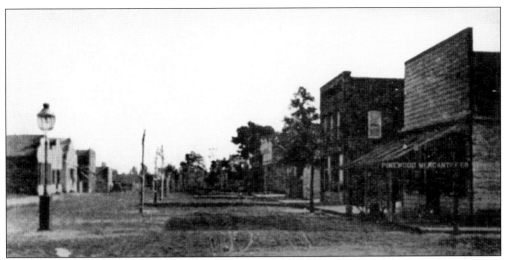

BUSINESS BLOCK, PINEWOOD. This is a view of the south side of East Commerce Street, looking east. Commerce Street was renamed Clark Street in 1925. The photograph is taken from East Avenue and shows the main street *c.* 1907. The Pinewood Mercantile Company occupies the frame building on the right side.

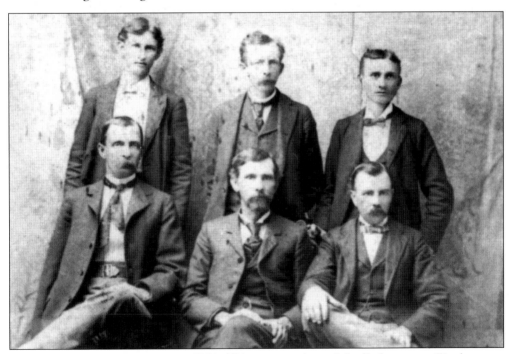

FIRST TOWN COUNCIL, PINEWOOD, 1902. This community, originally known as Pinelog, was incorporated on December 15, 1899, and called Clarendon. The Atlantic Coast Line refused to change the name of the depot, so on April 7, 1902, the town changed its name to Pinewood. The first town council was elected in 1902. The members, from left to right, were as follows: (front row) Mr. Patrick H. Broughton, Mr. Ashbey L. Burkett, and Mr. Samuel G. Griffin; (back row) Mr. David R. Lide, Mr. P. M. Salley, and Mr. Henry F. Stack. Ashbey L. Burkett was the intendant in 1899, and P. M. Salley was the intendant in 1902.

OLD POST OFFICE, PINEWOOD. This 1920s business block view, taken at the corner of East Avenue, shows the north side of East Commerce Street. Mr. Clark, owner of Milford Plantation, paid to have Commerce Street paved in 1925, at which time the street was renamed Clark Street. Pinewood was part of Clarendon County until 1921, when the residents voted to be annexed into Sumter County. An inducement was that Sumter County promised to build a paved road from Pinewood to Sumter. The southern boundary below Pinewood shifted again in March 1922 when a small portion reverted to Clarendon County.

OLD RICHARDSON STORE, PINEWOOD. The old Richardson Store was located on East Avenue with its back to the railroad and was near the Baptist church. This frame general store carried goods that a family would need for any activity for home or garden. It opened in the 1890s and was active through the 1930s. A car wash is now located at that site.

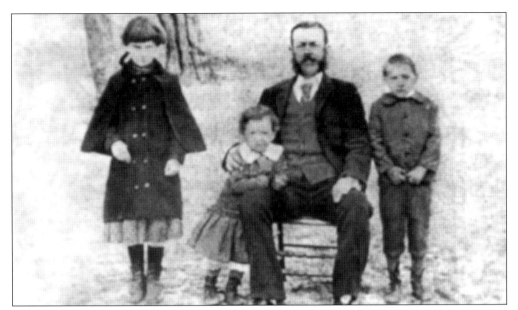

JOSEPH REID GRIFFIN FAMILY. This Griffin family portrait shows, from left to right, Oneida Virginia (1880–1971); Clinton Furman (1886–1936); Joseph Reid Griffin (1856–1924), father; and Joseph Dempsey (1882–1950). Mr. Griffin's first wife was Virginia Helon Parler (1861–1886), who is not in this picture. He married a second time; he and his second wife had nine children.

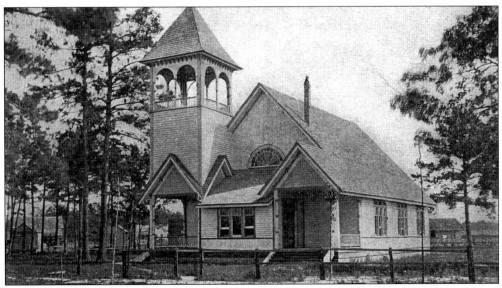

ST. JAMES METHODIST CHURCH, PINEWOOD. The St. James Methodist Church was founded in 1844 near the town of Pinewood. The congregation of St. James met in an old log building known as the "Pine Log Church." Worship services for the congregation were provided by preachers on the Santee circuit. Rev. H. H. Durant was the first circuit rider to visit the church and hold a revival. Eliza Griffin gave an acre of land for a church in 1874. The present-day sanctuary, located at 131 Clark Street, was constructed in 1898 and dedicated by Bishop W. W. Duncan in 1900.

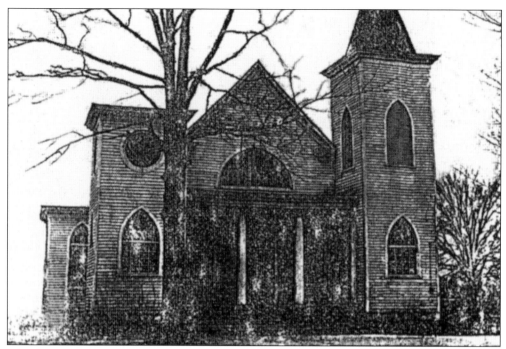

PINEWOOD BAPTIST CHURCH. The Pinewood Baptist Church was organized in 1908 with 33 members by Rev. J. N. Tolar. Early services were held in the Knights of Pythias hall over Stack's store. In 1908 R. F. Epperson gave the land on Fulton-Manning Street for the present church, which was erected in 1909.

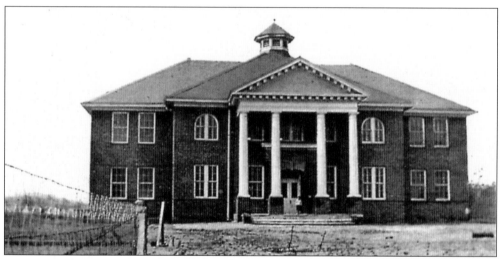

PINEWOOD GRADED SCHOOL, DISTRICT #27. The initial two-story frame schoolhouse for white pupils was built in 1894. In 1908 the two-story brick Graded School at Oak Lane was built to replace the first building; the new school housed elementary and high-school grades. The trustees were J. R. Griffin, N. L. Broughton, and P. M. Salley. It became the elementary school when the Pinewood High School was built. In 1915 F. T. McGill was the principal and there were six teachers and 120 students in a 32-week school year. This building was torn down in 1961.

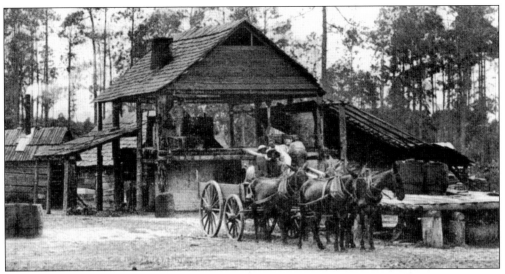

TURPENTINE STILL, POSTCARD. The 1878 McLaurin Sumter County map shows Brown's Turpentine Farm in Manchester Township, just below Shanks Creek near Bloom Hill plantation. Farmers could harvest their long leaf or slash pine trees for lumber, collect the rosin, and either place the rosin in barrels for use as pitch or heat it and, through distillation, create turpentine, a thin volatile essential oil used in products such as paint thinners and solvents. The postcard shows a turpentine still in operation. Barrels of turpentine could be sent by barge or rail.

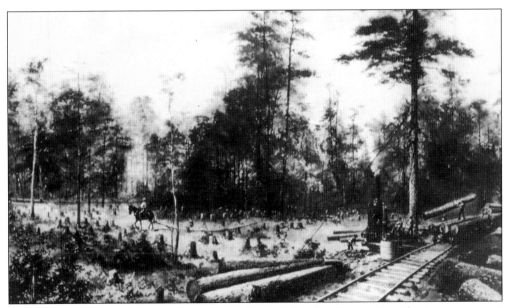

OUTRIDER HAULING A SNAKE TO LOAD LOGS. In early lumber harvesting, the trees were cut manually. Mules and/or oxen were used to haul the logs to the railroad tracks. This etching shows a worker riding a mule, which pulls a log using a rope and a pulley hung in a tree. The log is then lifted clear of the ground and swung over and placed on the bed of the flatcar. Makeshift techniques such as this were used to load logs onto the rail cars, which were then pulled to a nearby sawmill. Steam loaders replaced these loaders in the 1930s.

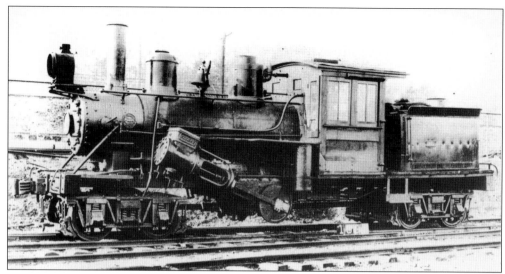

CLIMAX #534, SUMTER HARDWOOD COMPANY, 1921. The Sumter Hardwood Company was organized in 1920 by the Korn Company of Cincinnati, Ohio, after they had bought large tracts of timber near Sumter. They built a modern hardwood mill designed to cut 30,000 feet daily. It was supported by a logging outfit that used tank tread tractors to work in the woods and steam locomotives to transport the logs to the Sumter Mill. The Climax #534 steam locomotive was used in 1921.

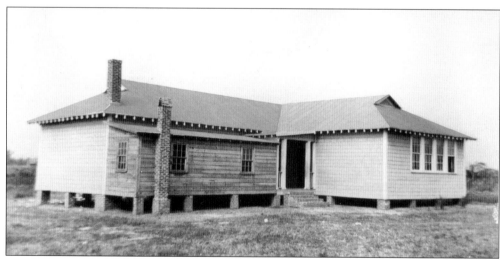

RIMINI COLORED SCHOOL, DISTRICT #27. The population of Rimini was 100 in 1910. In 1915 this one-teacher school had 111 students in a session of 60 days. It was located in the Rimini community at the intersection of Camp MacBoykin Road and West Avenue. Presently the old school building can be seen behind a blue building being used as a nightclub. Although scheduled to be torn down in 2002, the building is still standing. This site was in Clarendon County until 1921.

Two

PRIVATEER AND CONCORD TOWNSHIPS

Privateer and Concord Townships extend eastward from Cane Savannah Road to the Black River. Originally settled by small farmers, land holdings were quickly consolidated as the cultivation of cotton was introduced

The soil and weather are favorable for the production of cotton, corn, fruits, nuts, and vegetables. In recent years, large groves of pecan trees were planted as an alternative money crop. Cattle and dairy herds provide additional income to some of the farmers. Lumbering in the swamps harvested the virgin trees to meet the needs of the woodworking mills located in Sumter. Railroads created a number of small towns, but the county system of paved roads created in 1925 led to their demise. The area remains rural.

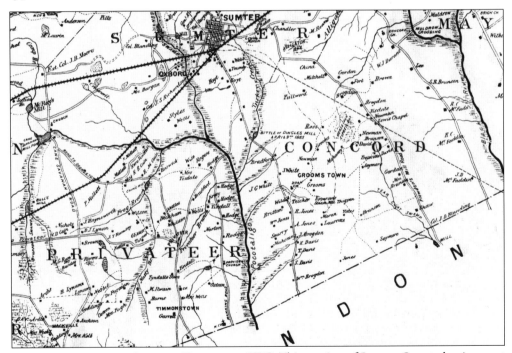

MAP OF PRIVATEER AND CONCORD TOWNSHIPS, 1878. This section of Sumter County begins west of Cane Savannah Road and extends eastward to the Black River and southward from Sumter to the Clarendon County line. Railroads, roads, swamps, bays, and other sites are indicated. Existing homes, plantations, churches, and schools are marked and named.

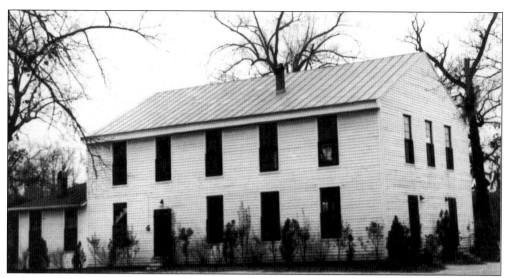

BETHEL BAPTIST CHURCH, PRIVATEER. Originally called Bethel-Black River, the church was organized in 1780 then dissolved *c.* 1800. The church was revived on April 29, 1810, and incorporated in 1823. The second church was built by 1828. The present building was constructed of wood in 1849 with a seating capacity of 500 and galleries for the black members. Hezekiah and James Nettles deeded 34 acres for use by the church in 1823, and John Blount Miller deeded two acres in 1840 for a white cemetery and additional land in 1842 for a black cemetery. In recent years the building has been modernized with brick veneering, stained-glass windows, and a towering steeple.

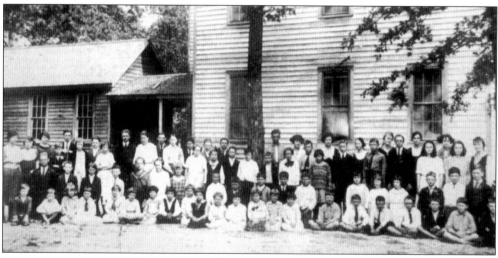

BETHEL SCHOOL, PRIVATEER DISTRICT #3, 1923. Originally established by Bethel Baptist Church, the school occupied a wooden building where Bethel Church Cemetery is now. In 1900 it was in the Privateer School District #3, which had seven white one-teacher schools with 134 students in a schedule of 140 days. W. O. Cain was the superintendent. In 1912 the 50 students in Privateer Township were transported by two wagons to the Bethel school. In 1913 the school had grown to a four-teacher school that had 134 students, and in 1915 it had 155 students. The school above was built *c.* 1919 and is located east of Bethel Church Road and south of Nettles Road. The building still stands.

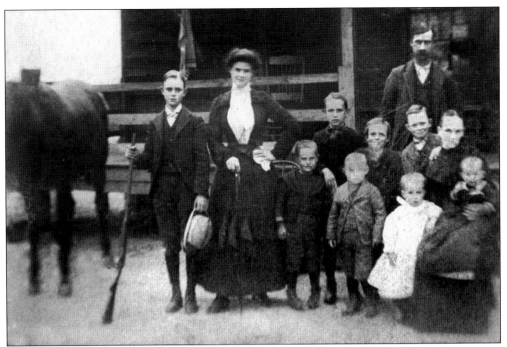

JACKSON FAMILY, PRIVATEER, 1902. The Jackson family stands in front of their home on Cain's Mill Road in the Privateer Section of Sumter County. Standing on the right is Thomas Jehu Jackson behind Mrs. Cecelia Alsbrooks Jackson (seated). The couple's children are (in no particular order) Tobitha, Moultrie, Kenneth, Riley, Beecher, Fallow, Willoford, and Lynwood.

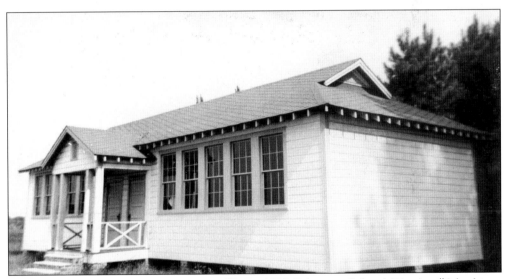

PRIVATEER COLORED SCHOOL, DISTRICT #3. In 1900 Privateer School District #3 had two black public schools and four private one-teacher schools with six teachers instructing 440 students in a 72-day schedule. In 1913 this two-teacher school served 125 students in an 80-day session. This school building was likely built as a WPA project in the 1930s. It is located on Beulah Cuttino Road, west of Old Manning Road.

PROVIDENCE SCHOOL, DISTRICT #24. The initial Providence School was built *c.* 1878 with Ms. Marty Mason being the first teacher. In 1900 this site was in Providence School District #7, which had two white public schools and four private one-teacher schools with six teachers for 126 students in a 160-day session. J. B. Raffield was the district superintendent. In 1913 this two-teacher school served 56 white students in a 140-day session through the seventh grade. Mrs. Fannings and Mrs. Evans taught here in 1919. The original building was replaced in 1918. It was located next to Providence Baptist Church on Old Manning Road, just north of the intersection with Banaca Circle.

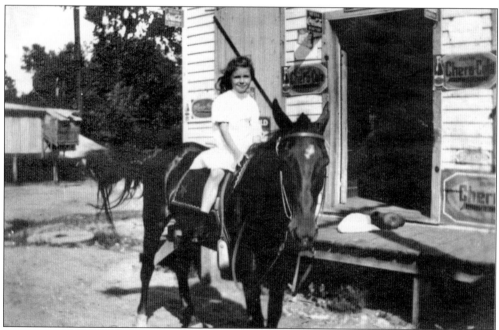

BRITTON'S SIDING COUNTRY STORE, *C.* 1920. The young Ernestine Smith Curtis Glover astride her horse is pictured in front of a Britton's Siding country store. Many rural communities had a general store similar to this one, where neighbors could purchase small items.

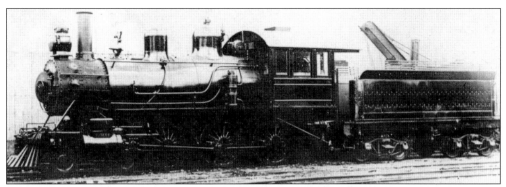

NORTHWESTERN RAILROAD, 1923. This rail line linked St. Paul and the lumber mills in Clarendon County to Paxville, Tindal, and on to Sumter and points north. Thomas Wilson (1846–1921), a wealthy lumberman, built a large pine mill at Cades and then built a logging line into the Black River Swamp heading west. Wilson became president of the Wilson and Summerton Railroad in 1888 and built an extension line from Wilson Mills to Jordon and to Summerton, with service offered in 1889 from St. Paul north to Summerton, Paxville, Tindal, and Sumter.

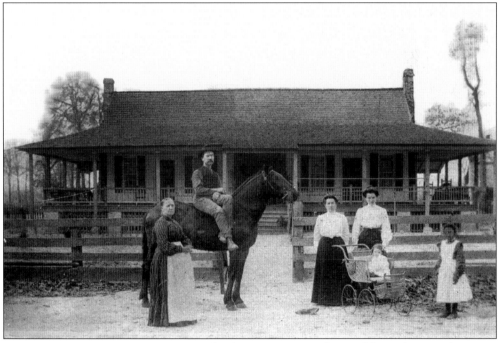

J. G. WHITE HOME, BRITTON, C. 1900. This home sat across the road from the Joseph Barton White residence and was the home of one of Joseph's sons. The family said that it was built to replace one that was burned by General Potter's troops during the Civil War. The house was destroyed in a 1920s fire.

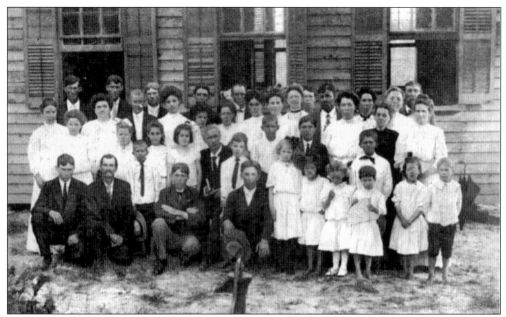

SINGLETON SCHOOL, DISTRICT #1. Charles Singleton gave land for the old one-room frame Singleton school. Mrs. Camilla Raffield was the teacher for many years. In 1913 the Singleton one-teacher school had 13 white students in a 160-day schedule.

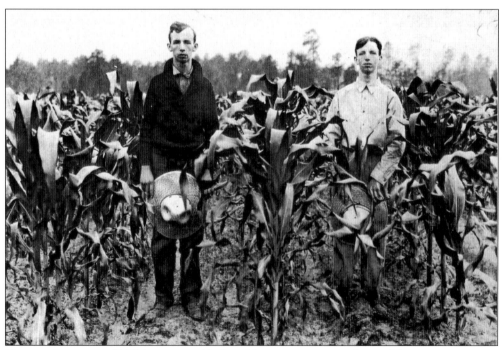

NEWMAN BROTHERS, 1925. Lonnie and Belton Newman were members of the Future Farmers of America and their 1925 4-H club project related to growing corn. The older children of farming families worked on special 4-H club projects so that they might discover improved farming techniques and new seeds that could yield larger crops.

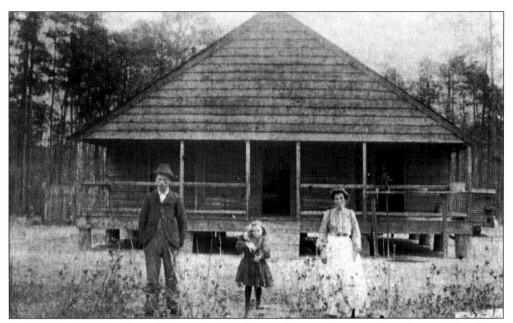

NEWMAN FAMILY AND HOME. This early 1900 home of Robert Eugene Newman (left) has Meta Newman in center and Mary "Mamie" Newman on the right. The site is in the Concord section of Sumter County near the home of William Jackson Newman.

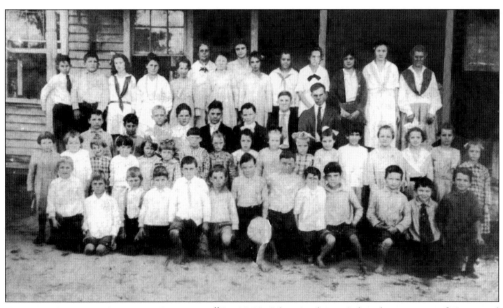

GRAHAM SCHOOL, CONCORD DISTRICT #2, 1919. The Graham School was one of Concord School District #2's six white one-teacher public schools in 1900. It had 147 students in a session of 120 days. In 1913 this two-teacher school had 30 students in a 146-day schedule. In 1919 there were 50 students—shown above—in grades 1 through 10 that were taught by Ms. Jessie McLean and Ms. Simpson in a three-room building. It was located on the eastern side of Old Manning Road just north of the Graham Baptist Church. Brogdon Memorial School replaced Graham School in 1926. (See the top of page 53.)

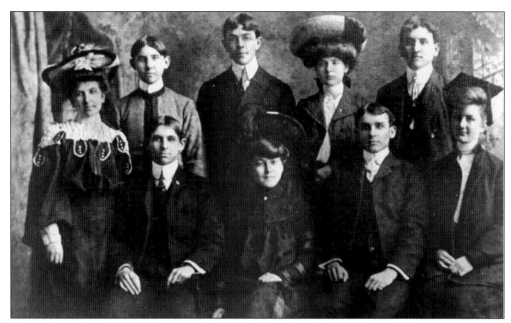

BROGDON YOUTH, 1906. Here are some of the people in the W. T. Brogdon community who met and entertained Ruby Swearingen (front center) on her visit to Brogdon, South Carolina, as a guest of J. C. Brogdon Sr.

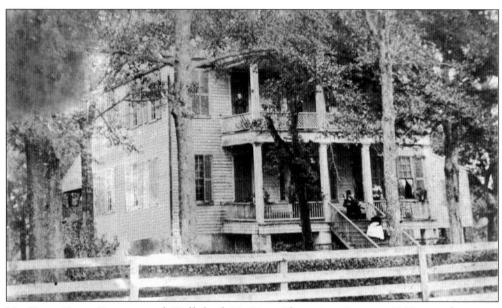

MT. HOPE. Henry Haynesworth Wells built Mt. Hope Plantation House *c.* 1838 on a plantation of about 2,000 acres. The house was located east of U.S. 15, about four miles south of Sumter. The four-story house was built by skilled slaves using clay bricks and hewn timbers made on the plantation. Wooden pegs of seasoned oak and hickory joined the beams, sills, and rafters of the house. Each floor had four large rooms. The first floor contained storage areas, a loom room, and a large kitchen. The family lived on the floors above. The attic could be used as a very large guest area on special occasions.

BROGDON MEMORIAL SCHOOL, DISTRICT #30, *C.* **1930s.** The Brogdon Memorial four-teacher school was opened in 1926 and replaced the old Graham School; it served the white pupils from the Brogdon and Britton communities. It closed in January 1956, and the students transferred to the new Mayewood School.

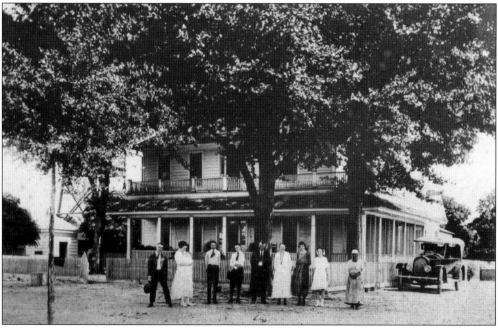

JAMES THOMAS BROGDON SR. HOME WITH FAMILY, *C.* **1918.** James Thomas Brogdon Sr. (1869–1945) and wife, Anna E. Bradham, created a community around his farm that expanded into a sawmill, cotton gin, gristmill, and country store. He was a trustee of the old Providence School. Teachers boarded at the Brogdon home, which was on Old Manning Road near its junction with Twelve Bridges Road.

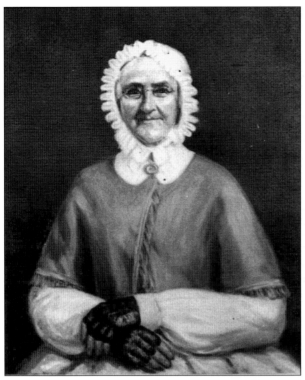

LEAH LENOIR DICKEY MCFADDIN (1772–1865). Matriarch and business executive Leah McFaddin started in obscurity and rose to a position of prominence. By her remarkable business ability, she amassed a great fortune. At the beginning of the Civil War she was the largest taxpayer in Sumter County. Her holdings were valued at $250,000. Her watchwords were thrift, frugality, and buy nothing until you can pay cash for it. She bore 10 children to her two husbands.

OLD MCFADDIN PLACE. Located about one mile from Concord Presbyterian Church, this house was built by Robert and Leah McFaddin following the purchase of the surrounding farm. A two-story house with tremendous rooms and halls, the large residence was surrounded by smaller plantation buildings, so the impression was a veritable hamlet with "Aunt Leah" as the "tribal head" of her home and her hundreds of slaves. Following her husband's death, she personally managed the plantation.

LIBERTY HALL, MCFADDIN FAMILY. Liberty Hall was built by James Dickey McFaddin (1805–1892). It was located on Brewington Road near the Sumter-Clarendon County line.

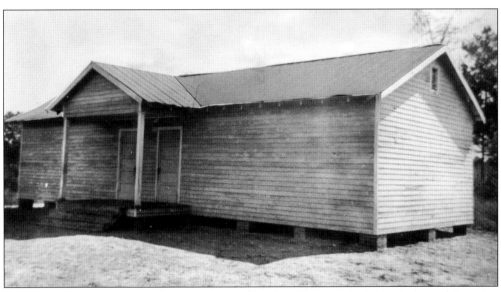

CONGRUITY COLORED SCHOOL, CONCORD SCHOOL DISTRICT #2. After the Civil War the Presbyterian Church U.S.A (north) organized the Congruity Presbyterian Church for the over 300 black members of Concord Presbyterian Church. The Congruity Colored School was built in 1875 to serve these children since the county did not build black schoolhouses. In 1900 these Congruity students went to one of Concord School District #2 six one-teacher schools that taught 447 black students in a session of 78 days. In 1913 this one-teacher school had 109 students in an 80-day session. It was located near Congruity Church at Congruity and Illery Roads.

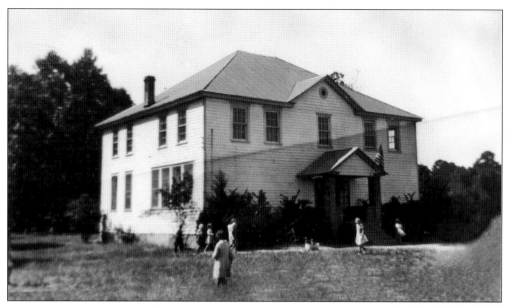

CONCORD SCHOOL, DISTRICT #2. The Concord School District #2 in 1900 had five white public schools and one private school with six teachers instructing 147 students in a session of 120 days. R. C. Blanding was the superintendent of this district. In 1913 this was a one-teacher school for 20 students in a 153-day session. Bessye Flynn was the teacher in 1915 with 94 students. It was located at the intersection of Plowden Mill Road and Boots Branch Road.

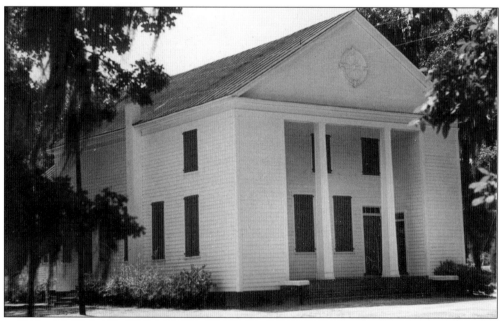

CONCORD PRESBYTERIAN CHURCH. The Concord Presbyterian Church, on Old Brewington Road, was organized in 1808 by Rev. George G. McWhorter, then pastor of Salem Black River; McWhorter served this church until 1815. The initial land was given by Gen. Thomas Sumter. Later, land grants were given by Reddin McCoy and Robert Muldrow. The longest serving pastor was Rev. W. J. McKay, who served from 1888 to 1920.

Three

MAYESVILLE AND SHILOH TOWNSHIPS

In 1870 the Shiloh, Mayesville, Lynchburg, and Bishopville Townships included all the land between Scape Ore Swamp and Lynches River. Lynchburg and Bishopville became part of Lee County in 1902, leaving Mayesville as the only large town in the eastern part of Sumter County.

Mayesville depot and town was named for Squire Matthew Peterson Mayes when the Wilmington and Manchester Railroad built a depot near his home in 1853. In 1909 Mayesville boasted many businesses. Rich farmland surrounded the town. With the paving of the highway to Sumter about 1922, business started a decline. This decline was accelerated by the Depression in the 1930s. Today, Mayesville is a small rural town.

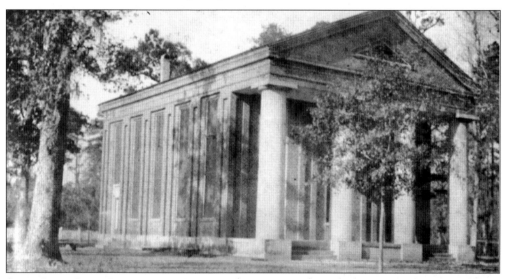

SALEM BLACK RIVER PRESBYTERIAN CHURCH. The present Salem Black River Presbyterian Church is the third building on this site on Taylor's Swamp that was given by David Anderson in 1759. A log cabin was built in 1759, followed by a frame building in 1768 and a brick structure in 1802. The nickname "Brick Church" came from the 1802 building. The present sanctuary was built in 1846 from bricks made on the site. Four Doric columns, each four feet thick, decorate the front of the church. They withstood the earthquake of 1886, but earthquake rods had to be installed in the walls. Salem Black River Church is the first church organized in St. Marks Parish and is the "mother church" of all Presbyterian churches in Sumter County. It is located at 1060 North Brick Church Road.

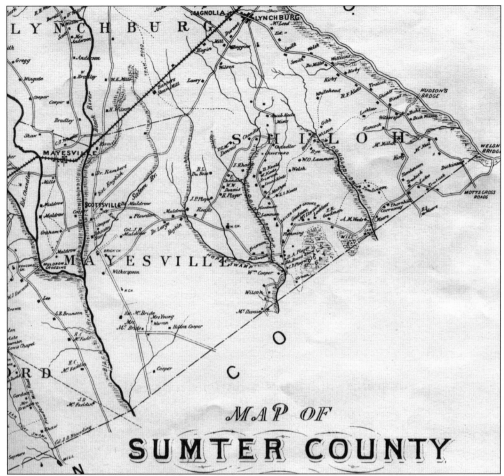

MAP MAYESVILLE/SHILOH SECTION, SUMTER COUNTY, 1878. This area was once a part of Salem County, from 1792 to 1800. The narrow east-west extension of Sumter County from the Black River to the Lynches River boundary is broken with north-south creeks and swamps that hampered travel to and from the county seat. The natural features of swamps and bays are marked, along with early roads and the significant churches, homes, and plantations. The historic Black River Presbyterian Church is marked as "brick ch" and is positioned by the "Y" in Mayesville. (Woods) Mill Bay is located along the Clarendon boundary in the Shiloh area.

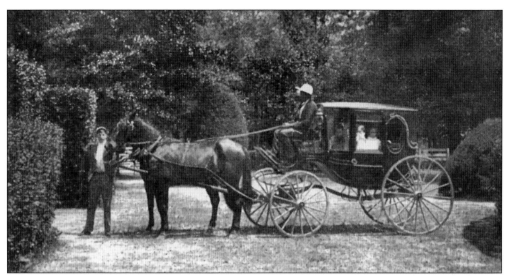

COACH, COLDSTREAM PLANTATION. This coach was used to bring visitors to Coldstream Plantation from the train depot in Mayesville in the 1900s. The gardens of this plantation, shown in the background, were renowned for their beauty in all seasons. Started by Robert and Elizabeth Witherspoon *c.* 1824, they were developed by their son, Hamilton G. Witherspoon and his wife, Nancy, under the supervision of a German gardener. Their daughter, Mary Witherspoon, maintained the gardens until her death in 1905.

COLDSTREAM PLANTATION. Robert Witherspoon, great-grandson of John Witherspoon who settled in Williamsburg Township in 1734, purchased land from Capt. John B. Anderson in 1813 and named his plantation Coldstream after a small town in Scotland where the Coldstream Foot Guards Regiment originated. Robert's second wife, Elizabeth McFaddin, inherited land from her father in 1824 that became part of the plantation. The plantation adjoined the property of Salem Black River Church where Robert was a ruling elder. The plantation was sold to a cotton farmer in 1911. He cut down the trees and plowed up the gardens for a cotton field. The house shown in this photograph was allowed to decay into ruins.

RIP RAPS HOUSE. The original Rip Raps Plantation land grant of 500 acres was made to Peter Mellette in 1750. It stretched eastward from the Black River in the old Salem community and once comprised 10,000 acres. The land was sold to James Bradley. The third residence was built for Samuel McBride in 1860. The house has 14 rooms, each measuring 20 feet by 20 feet, with a wide hall extending the length of the building. Both the front and the back are exactly the same.

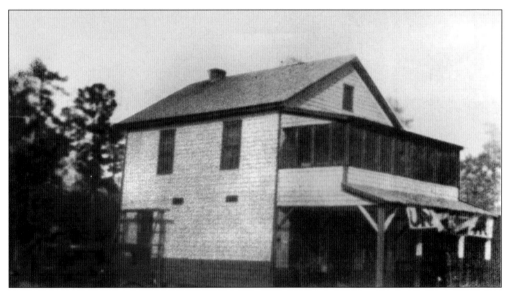

DABBS STORE, DABBS CROSSROADS. Eugene Dabbs Sr. owned this store at the intersection of S.C. 527 and U.S. 378. He hired Charles McFaddin to run the business for him for many years. The store closed in the 1990s, but it is now being used by Dickie Dabbs, a nephew, to manufacture outdoor furniture.

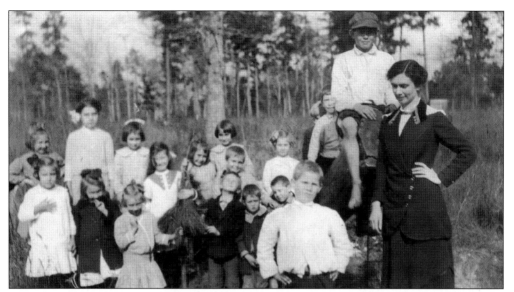

STUDENTS AT SALEM SCHOOL, DISTRICT #15. In 1900 Mayesville District #15 had three white one-teacher schools for 36 students in a 96-day session. In 1913 this one-teacher school in Mayesville School District #15 had 15 students in a 158-day session. Ms. Julia Lide was the teacher in 1921.

JAMES MCBRIDE DABBS, FARMER. James McBride Dabbs (1896–1970) lived at Rip Raps from 1937 until his death and farmed 125 acres of the old plantation for a time. A former professor at the University of South Carolina, he was the head of the English department at Coker College for 17 years. Dabbs wrote *Southern Heritage* in 1958 and two other books. From 1957 to 1963 he was president of the Southern Regional Council.

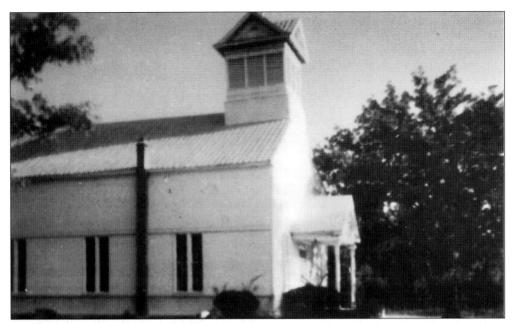

GOODWILL (AFRICAN-AMERICAN) PRESBYTERIAN CHURCH, 1867. With the help of Rev. Jonathan Clarkston Gibbs, missionary from the Presbyterian Church U.S.A. (north), Goodwill Presbyterian Church was organized in 1867 by former slaves who were members of the Salem Black River Presbyterian Church. Goodwill was the second church he organized. With banners flying, the members marched down Brick Church Road to the two-acre tract of land donated by Hamilton Gilliard Witherspoon, owner of Coldstream Plantation. A church and a parochial school were built *c.* 1870. The first pastor was Rev. Dr. West.

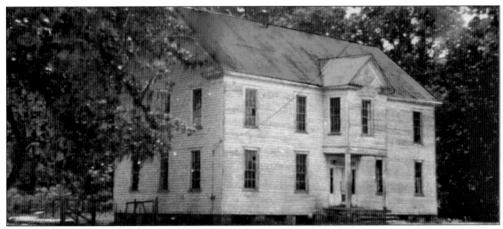

GOODWILL PAROCHIAL (AFRICAN-AMERICAN) SCHOOL, 1872. Soon after the Civil War 100 black slaves in the Black River Presbyterian Church congregation were organized into the Goodwill Presbyterian Church. Church missionaries established Goodwill Parochial School, originally called Salem Day School, to educate the black children of that community. The church had to do this since neither county nor state funds were available for black education. In the early 1900s the school enrolled 371 students, of which 350 came from Presbyterian homes. It had a staff of four teachers. Students walked as many as seven miles each way each day to attend classes. The school still stands and is on the National Register of Historic Places.

REV. I. D. DAVIS, GOODWILL PRESBYTERIAN CHURCH, U.S.A. The Rev. Dr. Irby D. Davis (1858–1932) was Goodwill Presbyterian Church's second minister from 1898 to 1924. It is the second oldest African-American church in Sumter County. Over the years about 30 youth from the congregation have been ordained as ministers in various denominations.

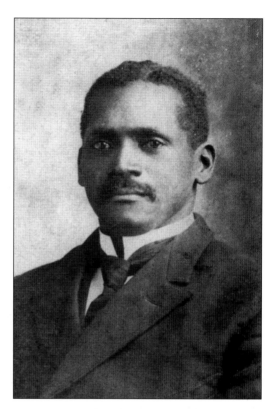

GOODWILL COLORED SCHOOL, MAYESVILLE, DISTRICT #15, 1930s. In 1913 this one-teacher black school had 293 students in a 99-day session. This building was built *c.* 1930. The school was an anchor of this vital community, educating countless students, many of whom became doctors, teachers, and ministers as well as businessmen, farmers, and homemakers. The school remained open until the early 1960s. The site is on Brick Church Road next to Goodwill Church.

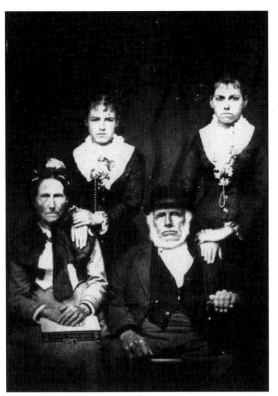

PLAYER FAMILY, SHILOH. This is a photograph of Christopher Turner Player (1817–1889); his wife, Mary Jane (Polly) Buddin Player; and the two youngest of their daughters, Susan Adiline Player (1862–1883) and Agnes Vermelle Player (1864–1939). They had 12 children. Christopher Player was crippled as a child but was an industrious and successful farmer. Christopher Player was one of eight children. Three of his siblings married other children of the Buddin family, who owned the adjoining farm. Both families were original pioneers and were large landowners.

GREEN'S STORE, SHILOH. Green's Store on S.C. 58 in Shiloh was constructed of concrete blocks made on site by a contractor from North Carolina. Work began in 1905 and was finished in 1906. The picture shows, from left to right, David McSwain Green and his sons, Walker Thomas Green and William Wherry Green, and two unknown employees. The store was sold to the Myers family during the Depression, and they operated it until the 1970s. The building still stands.

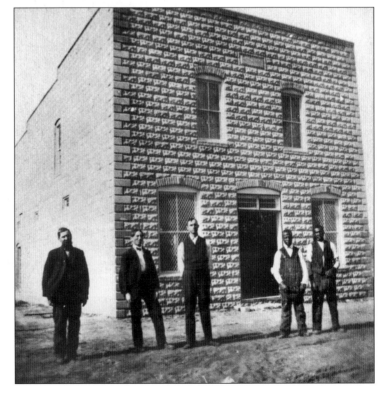

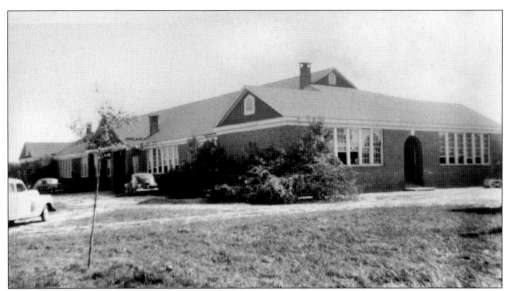

SHERWOOD SCHOOL, SHILOH SCHOOL DISTRICT #33. In 1900 Shiloh School, District #14, had 10 white, one-teacher schools with 333 pupils on a 160-day session. R. W. Green was superintendent. In 1913 Shiloh School had one teacher for 48 students on a 138-day session. After Shiloh was torn down, Sherwood School was built in 1937 to accommodate the white Shiloh students and those living in the eastern part of Sumter County. C. B. Epting was the principal. Six grammar teachers taught 196 students, and four high-school teachers taught 85 students. Materials from Shiloh School were used to build Sherwood School. It is located at the intersection of Pudding Swamp Road and Narrow Paved Road.

SHILOH METHODIST CHURCH. The Shiloh Methodist Church was built *c.* 1835 on Woods Bay Road, near Pudding Swamp Road. John Frierson of Sumter District gave the land to Henry Goodman and others for the construction of the church. Shiloh had a population of 150 in 1910.

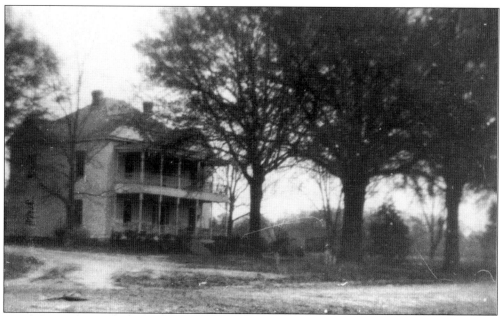

A. J. GOODMAN'S HOUSE, SHILOH. Adolphus Junious and Rebecca Goodman's house was built between 1910 and 1914. It incorporated several unique features for that period. The chimneys are enclosed, and there is a two-story front porch. The house is located on S.C. 58, between Shiloh and the entrance to Woods Bay. It still stands.

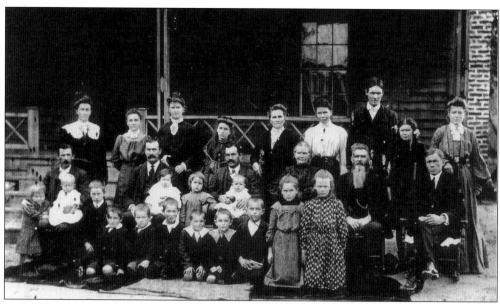

JAMES AUGUSTUS MACDONALD CARRAWAY FAMILY PORTRAIT, *C.* 1901. James Augustus MacDonald "Macs" Carraway (1835–1932) served in the Confederate Army. Later, the United States Postal Service operated a post office in his home. The address was Max, South Carolina. Max had a population of 30 in 1910. Carraway is in the second row, right side, with the long beard. Carlyle W. Goodman is the baby on the left side of the photo. The house was located two miles north of the entrance to Woods Bay on Norwood Road and no longer stands.

CARLYLE W. GOODMAN, *c.* **1930.** Goodman was a state legislator from 1956 to 1973 and was chairman of the agriculture and conservation committee in the house of representatives. He owned a large farm near Woods Bay. Goodman had three sons. While only five feet and one inch tall and weighing only 120 pounds, he was physically strong and gregarious. The farm was based on a governor's grant made in 1813.

ADOLPHUS JUNIOUS GOODMAN'S STORE. This store was operated by A. J. Goodman from about 1890 to 1914. It is located on S.C. 58, between Shiloh and Woods Bay. The interior features hand-planed cypress logs. The building is still standing.

ST. JOHN'S METHODIST CHURCH, SHILOH. In 1879 the Methodist circuit rider Rev. Nathan Hall led the African Americans living in the area near the Locklair farm to form a Methodist church on the Old St. John dirt road on a site donated by Mr. And Mrs. Henry Keels. Founding members included Rev. S. Canady, Rev. A. Durant Sr., I. Epps, J. Hickson, E. Moore, A. Nelson, and J. White. In 1945 the church moved to a new site on Narrow Paved Road near Old St. Johns Church Road and a modern sanctuary was built there.

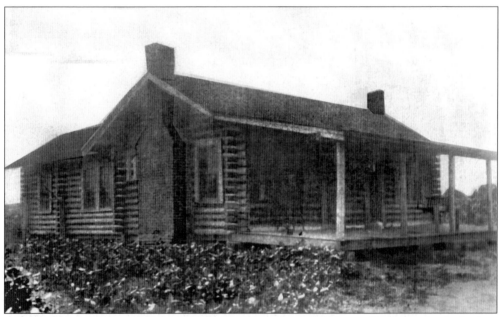

C. HARRY TRULUCK'S LOG HOUSE, 1920. Harry Truluck and his wife, Lonie, built the last house constructed using logs in the Shiloh area. The site is at the intersection called Hobbs Crossroads today. Previously it was known as Motts Bridge Crossing, as there was a bridge across Lynches River.

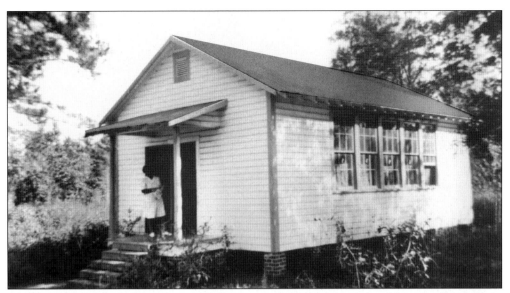

St. Marks Colored School, District #13. In 1900 Lynchburg School District #13 had six one-teacher black schools for 514 students. This school was on the grounds of the St. Marks A.M.E. Church, which was organized in 1877 by Rev. Miller Brown. The school was a one-teacher school with 64 students in a session of 60 days in 1913. The site is located near Hobbs Crossroads, on the southwest side of Lynches River Road near Yarborough Road.

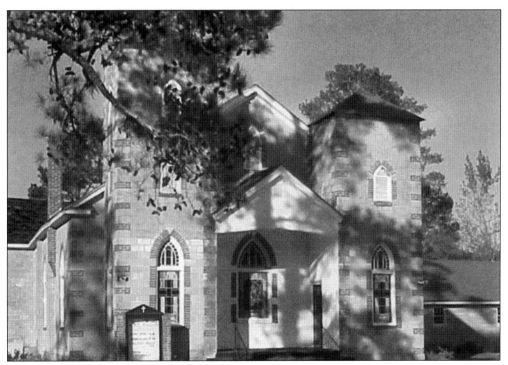

Mt. Sinai A.M.E. Church, Shiloh. In April 1893 a one-acre lot was purchased from D. L. Dennis for $10 for the Mt. Sinai A.M.E. Church. The church was built for a small congregation. A new building constructed in 1948. The site is on Mt. Sinai Church Road near Interstate 95.

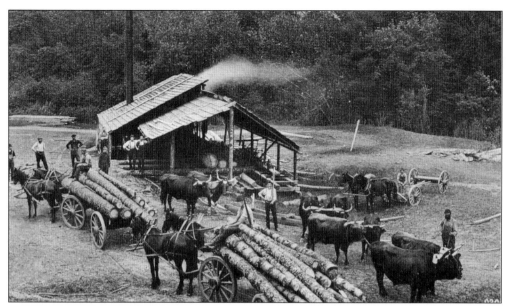

SAWMILL POSTCARD, 1908. This postcard view of a small rural sawmill shows the logs being hauled in from the forest by mule or ox teams. A steam engine drives the saws that cut the logs into rough lumber. The lumber provided by this mill could be used for barrel staves or in construction. The best quality lumber would be sent to a larger mill, where it would be dressed and planed for use in manufacturing furniture or other quality wood products.

CYPRESS TREES IN ONE OF THE BAYS. Logging did go on in the Shiloh area until at least the end of World War II. The operations mainly involved the logging of cypress trees from so-called "cypress ponds." The operation shown in the photo on the bottom of page 71 would have been typical of some of the operations.

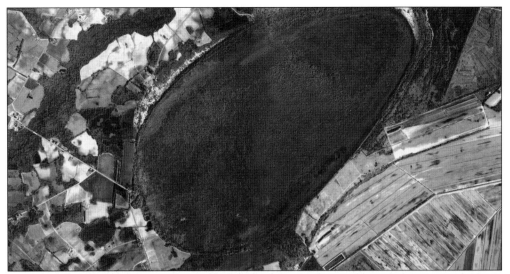

WOODS BAY STATE NATURAL AREA—AERIAL VIEW. Woods Bay, which extends from Clarendon County into Sumter County, is one of several hundred thousand elliptical depressions that are scattered in an arc from the Florida panhandle to Delaware. It is presumed that these sites were created by meteorite showers that struck this area. Locally called "Carolina Bays," most of these depressions have been logged and drained. Woods Bay, a cypress-tupelo swamp, was acquired by the state in 1973 and designated a natural area. It is being studied and monitored to determine how best to manage these habitats.

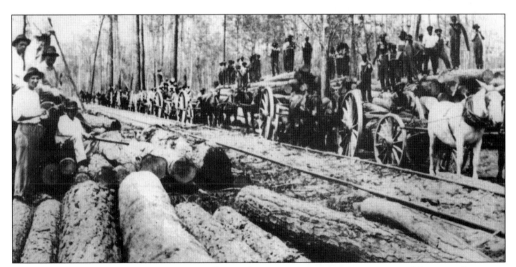

LOGGERS HAUL LOGS TO A RAILROAD. In larger logging operations, crews would use mule teams to haul logs to a railroad. Here the logs would be loaded onto railcars to be hauled to the main sawmill for finishing to commercial standards. Because of its pine and hardwood forests, Sumter County became well known as a manufacturing center for quality furniture.

MAYESVILLE TOWN HALL, 1912. Mayesville was chartered in 1874 with Dr. J. A. Mayes as intendant and Robert P. Mayes as clerk and treasurer. This building at 220 Main Street served as a liquor dispensary from 1893 to 1907. It is the town hall but has also served as fire department and jail. In 1911 the city was concerned about lost revenues due to the closing of the dispensary but confident that property taxes would not have to be imposed. The population in 1910 was 800.

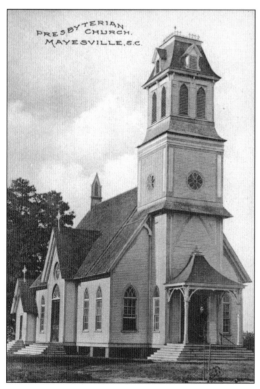

MAYESVILLE PRESBYTERIAN CHURCH, 1908. Mayesville Presbyterian Church was organized on January 8, 1881. The first meetings were held at Masonic Lodge #141. Matthew Peterson Mayes II donated the lot. The new church was dedicated on April 17, 1892, with Rev. Cuttino Smith as pastor. Built in the Roman-Gothic style, it has a capacity of 400. Other pastors were J. E. Stevenson, H. A. Know, R. L. Grier, J. W. Grooves, D. McNab Morrison, D. M. Hill, and J. F. Aiken.

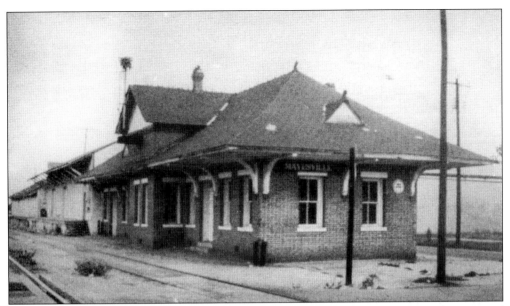

MAYESVILLE DEPOT, 1908. The Wilmington and Manchester Railroad built the original Mayesville Depot in 1853 near the home of Matthew Peterson Mayes. General Potter burned that depot in 1865, and a new depot was built in 1880. The brick depot pictured above was built in 1904. In the early 1900s, six passenger and numerous freight trains served the town daily. The rail line was abandoned *c.* 1980, and the depot was torn down.

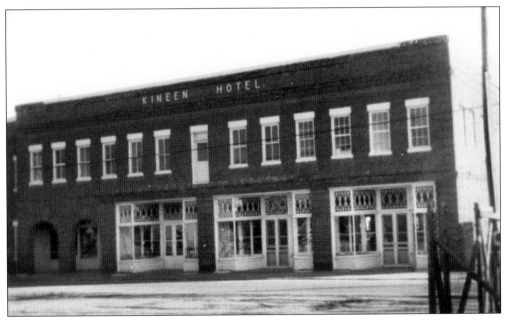

KINEEN HOTEL, MAYESVILLE, 1911. W. N. McElveen built the Kineen Hotel on Main Street across from the new depot on property he bought from H. C. Bland. The up-to-date hostelry had three storerooms on the ground floor. Drummers arrived by train and stayed here while calling on local customers. A livery stable was located on the other side of the depot that rented horses and buggies.

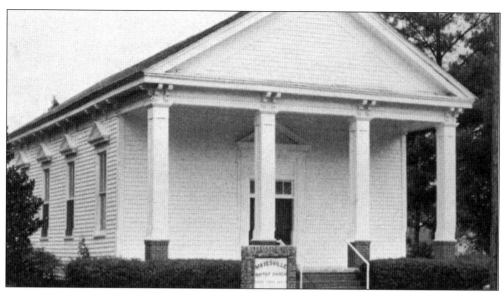

MAYESVILLE BAPTIST CHURCH, 1916. Mayesville Baptist Church was organized in 1879 under the leadership of missionary M. L. Ball. The church building was dedicated in June 1881 on land donated by C. D. Wheler and had a membership of 15. Rev. James A. Couser was pastor from 1881 to 1882. In 1912 the church was disbanded, but it was then reconstituted in 1916. The building was repaired at a cost of $773.50, and services were held twice a month until 1951. The church was disbanded in 1995 and the property sold.

ROBERT J. MAYES JR. HOUSE, 1912. Squire Matthew P. Mayes II, founder of Mayesville, lived at the 3,000-acre Muldrow Plantation south of Mayesville Depot. This cotton plantation had 300 slaves. The great-grandson of Squire Matthew P. Mayes, Robert J. Mayes Jr. built this house in 1910. Robert was described in the *State* in 1911 as "an enterprising younger merchant who conducts a general store originally founded by his grandfather. He owned a cotton gin, valuable real estate in town, and extensive farmlands nearby." This house is being restored.

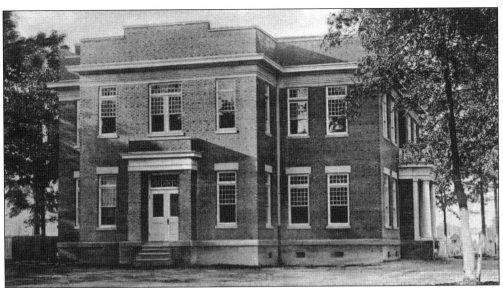

MAYESVILLE HIGH SCHOOL, DISTRICT #18, 1911. Ms. Elizabeth W. Brearley taught in a one-room school in 1883. In 1900 Mayesville had one public and one private white school with two teachers for 58 students in a 32-day session. J. R. Mayes was the superintendent. The library was started in 1905. The school above was built in 1910 at a cost of $9,500, with $7,000 being provided through a bond issue. The architect was J. H. Sams of Columbia, and the contractor was T. B. Fort of Mayesville. W. H. Jones was principal, and Ms. Alice Cooper and Ms. E. Mayes were assistants. In 1913 the school had 100 students in a 179-day session. The school was closed following consolidation of the school districts in 1955.

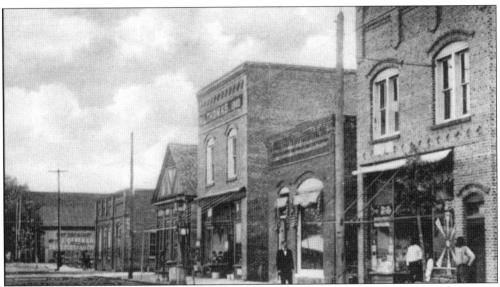

LAFAYETTE STREET LOOKING SOUTH, 1911. A set of Mayesville postcards was published by Bradley and Thomas. The commercial buildings pictured here housed a general store, furniture store, hardware store, bank, and post office. Other stores in Mayesville in 1909 included a department store, jewelry store, two drug stores, grocery stores, a second bank, five doctors, and an undertaker.

Lowry Institute, 1915. Lowry Institute was a private school operated by a Methodist preacher for black children. In 1913 it was a two-teacher school with 194 students in a 39-day schedule. Farmers and sharecroppers sent their children to this school because the session started after harvest and ended before planting. The curriculum provided a very basic education. The school was disbanded in the late 1930s.

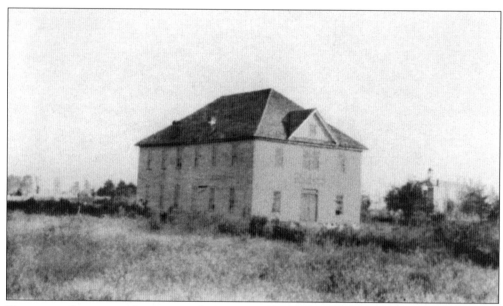

Mayesville Industrial Institute, 1915. Mayesville Industrial Institute was begun in 1882 and chartered in 1896 by Presbyterian Church U.S.A. (north) to educate black children. It was a boarding school with an initial 22-room building, several smaller buildings, a 70-acre farm, two mules, and other livestock. Later two other large buildings were added. Girls were taught dressmaking, cooking, and related subjects, and boys were taught shoemaking, blacksmithing, carpentry, and elementary agriculture. Fees ranged from 10¢ to 25¢ per month, and boarding students paid $1 per year.

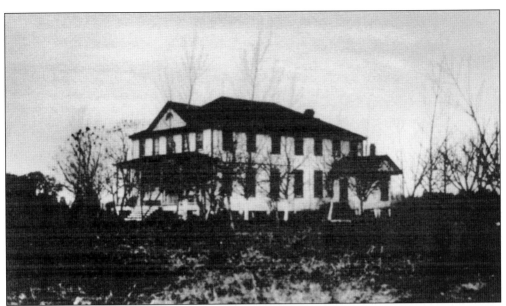

BILLINGS HALL, 1915. Billings Hall was the boys' dormitory and classroom at Mayesville Industrial Institute in 1915. Ms. Emma Jane Wilson, a student at Goodwill Parochial School and educated at Scotia Seminary in North Carolina, was sent to establish a school for black children. She started with an abandoned gin house and some borrowed books. Locally, the school was known as Little Tuskegee. It had six buildings and a 122-acre working farm. In 1915 this school had 15 teachers, 151 boys, and 249 girls in a 100-day schedule.

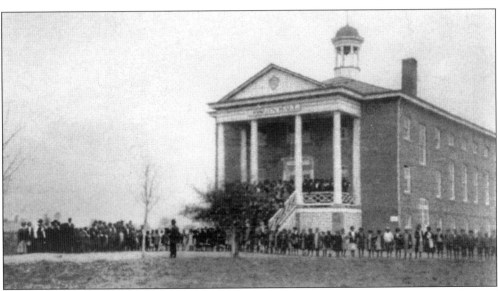

JOSYLN HALL, MAYESVILLE INSTITUTE, 1915. Josyln Hall, built in 1914 at a cost of $18,739, was a three-story brick building that housed offices, faculty room, library, chapel, dining room, kitchen and pantry, classroom, laundry, and boiler room. Emma Wilson died in 1924 and is buried on the grounds. Dr. Mary McLeod Bethune attended the school. The state took over the institute in the 1950s, and an elementary school was built on the site.

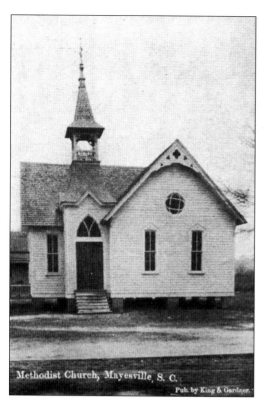

Methodist Church, Mayesville, S. C.

Pub. by King & Gardner.

METHODIST CHURCH, MAYESVILLE, 1911.
The Methodists built this small, pretty
church building on LaFayette Street.
It was said that while their numbers
were small, the congregation made
up for it with enthusiasm and loyalty.
Rev. Tracy W. Munnerlyn was pastor in
1911. This church was decommissioned
in 1935, and the building was sold to
another denomination. The building was
torn down. This *c.* 1910 postcard was
published by King and Gardner.

EBENEZER A.M.E. CHURCH, *C.* 1920.
Ebenezer A.M.E. Church was organized
in March 1872. A simple log church
was built that fall on land purchased
from the McCutcheon family. Early
members were named Wilson, McIntosh,
Hudson, Williams, Jefferson, Mayers,
and Anderson. The second building was
erected in 1918 under the leadership of
Reverend Sumter. It stood for 50 years.
Early pastors were Reverends Wells, Long,
Delaine, Boyd, and Fordham.

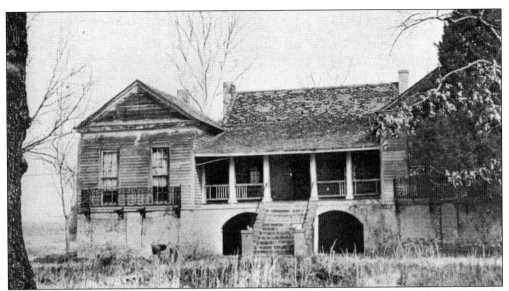

CHANDLER HOME, NEAR MAYESVILLE. This was the home of Gen. Samuel Rembert Chandler, who died in 1862, and it was where Agnes Drusilla Chandler McLaurin, wife of Daniel McLaurin, grew up. This house was located on Bell Road. General Chandler's widow, Mary Jacqueline Chandler, married Dr. C. R. F Baker. Their son, Dr. Samuel Chandler Baker (1866–1918), established a medical clinic in Sumter in 1894. It became part of the Tuomey Hospital. He served as president of the Sumter Chamber of Commerce in 1911. He worked to create the council-manager form of city government in 1912 and organized the Baker School near Mayesville.

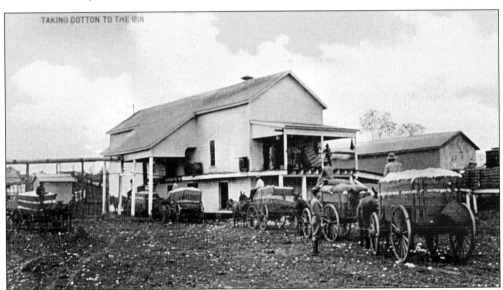

COTTON GIN POSTCARD. The local cotton gin was where farmers took their cotton to be ginned (have the seeds removed) and baled. Every community had at least one cotton gin, usually owned by a large planter, the owner of the general store, or another businessman. Mayesville had four cotton gins in 1915, Dalzell had two, and Pinewood had several gins at that time. This postcard shows a relatively small cotton gin.

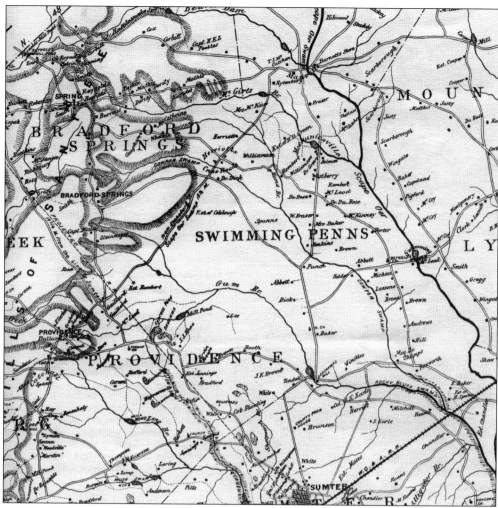

MAP OF SWIMMING PENNS, BRADFORD SPRINGS, AND PROVIDENCE TOWNSHIPS. This northeastern section of the 1878 M. H. McLaurin map shows the townships of Swimming Penns, Bradford Springs, and Providence. The land east of Scape Ore Swamp and north of Mayesville became Lee County in 1902. A small portion of the Wilmington, Columbia and Augusta Railroad is shown in the lower right corner, and a projected railroad path towards Camden is shown by a straight line on the left side of the map. Unusual early names, such as Swimming Penns, are used. The name came from the practice of keeping livestock on naturally enclosed fields surrounded by swamps where the cattle would stay and graze. The stock would have to swim to get in or out of that enclosed site.

Four

PROVIDENCE TOWNSHIP

The northern portion of Sumter County includes three areas renowned for their natural springs. Bradford Spring (Spring Hill) was a favorite summer retreat for antebellum Lowcountry planters, while Swimming Penns (Oswego) was known for the camp meetings held there by the Methodist Church. Providence Springs (Dalzell) remained a favorite resort area well into the early 1900s with a dance hall, a pavilion, and other facilities.

In 1901 the Northwestern Railroad opened a line between Sumter and Camden that created the towns of Dalzell, Borden, and Rembert. Dalzell, unlike the other towns, continued to grow because it had both good rail and road connections. With the opening of Shaw Air Force Base, Dalzell became a place for military families to live.

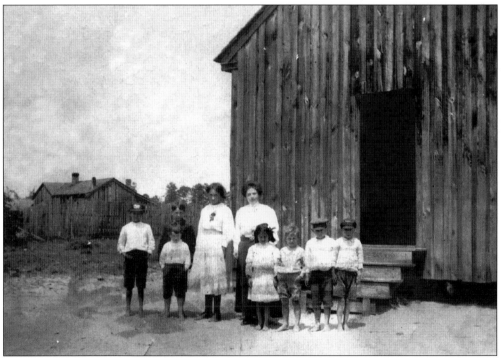

ROCKY BLUFF SCHOOL, 1910. The Swimming Penns School District #16 in 1900 had two public schools and one private white school with three teachers for 63 students in a 60-day session. Rocky Bluff School was located on the south side of Rocky Bluff Swamp, east of the Oswego Highway, near the Scarborough Lumber Camp. Mrs. Moore taught at this one-room school for some time. The building was constructed of rough boards that ran vertically on the wooden framework.

OSWEGO SCHOOL, DISTRICT #16. The Swimming Penns School District #16 in 1900 had two public schools and one private white school with three teachers for 63 students in a 60-day session. D. G. Rembert was the superintendent. The school in the railroad depot village of Oswego operated from 1911 to 1956. In 1913 this two-teacher school had 54 students in grades one through seven and a session of 157 days. In 1915 J. M. Stackhouse was Oswego's teacher for 54 students. It was located east of Oswego Highway at Foxworth Mill Road in the community of Oswego. Oswego's population in 1910 was 100.

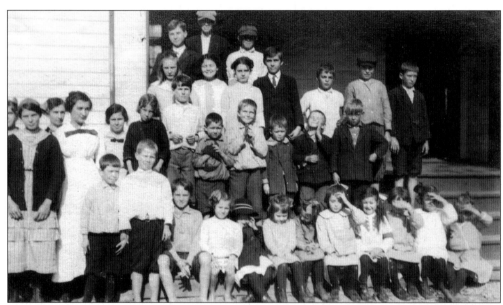

CLASS, BAKER SCHOOL, SWIMMING PENNS, DISTRICT #16, 1916. In 1902 District #16 had two public schools and one private white school with three teachers for 63 students in a 60-day session. This school was built *c.* 1911 in a location once called Buzzards Roost on land donated by Dr. Samuel Chandler Baker. Baker School began as a one-teacher school with 55 students. In 1911 Mrs. M. J. Moore described the building as having an alcove, cloakrooms, and two classrooms that could be opened to form an auditorium. In 1913 it was a two-teacher school with 55 students in grades one through eight and a 115-day session. It was located on the Old Brewington Road, near McCoy Road.

HOWARD CHAPEL COLORED SCHOOL, MAYESVILLE, DISTRICT #18, c. 1930s. Prior to the Civil War, it was illegal to educate slaves. One punishment for slaves who taught slaves was to cut off the thumb of the teacher so he or she could not form letters of the alphabet. During Reconstruction, Northern missionaries helped organize black churches, built schools, and began to teach children to read and write. South Carolina provided no money for public schools until after 1900. The Mayesville School District #18, which included Howard Chapel School, had two one-teacher schools for 271 black students in a session of 32 days in 1900. The site was between Mayes Open Road and Bethany Road.

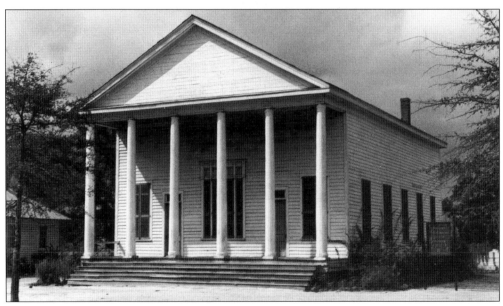

BETHEL METHODIST CHURCH, OSWEGO, 1920s. In 1856 James W. Rembert, desiring to unite three small Methodist groups into one congregation, donated two acres, lumber, and slave labor to build a church. The building was completed and dedicated in 1857 with the Rev. Bond English as its first pastor. The building was renovated in 1887 and the slave gallery removed. A chapel was added in 1966. The church is located at the intersection of Lodebar Road and Leonard Brown Road in Oswego.

GOAT MAN, c. 1930s. The Goat Man's name was Charles (Ches) McCartney of Zebulon, Georgia. He lived the life of an old-fashioned gypsy peddler. He and his wife and child went from town to town selling pots and pans and doing small chores for food money. A team of goats pulled the wagons, piled high with goods, tents, and personal items, while the family walked alongside. The Goat Man and his child wore goatskin clothing, and the family slept by the side of the road. The postcard above was sold by McCartney to make money.

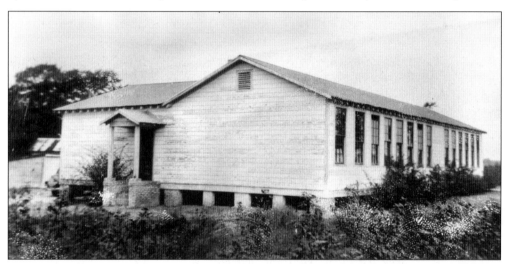

CLARK COLORED SCHOOL, SWIMMING PENNS (OSWEGO), DISTRICT #16. Clarks A.M.E. Church was created in 1856, when the white members of Clarks and two other Methodist congregations left their (initial) church sites to form the white Bethel Methodist Church. Clark Colored School was started by the black members of this church on its grounds. In 1900 the Swimming Penns School District #16 had three public schools and one private black school with four teachers for 276 students in a session of 48 days. In 1913 this one-teacher Clark School, Oswego District #16, had 107 students in grades one through seven and a session of a 100 days. Later a larger building was constructed. It was located near Clark Church at Cowpens Creek, south of Oswego on the west side of Oswego Highway. The building no longer stand.

DuBose School, Mechanicsville, District #19. The Mechanicsville School District #19 in 1900 had three white public one-teacher schools for 46 students in a 48-day session. Dr. W. W. Fraser was the superintendent. In 1902, when Lee County was formed, District #19 was renamed DuBose District #19. DuBose School was originally built across from Hebron Presbyterian Church. In 1921 Colzy Heriot was the teacher for grades one through seven. After this earlier building burned in 1923, a three-room replacement was constructed at the Dubose Siding location. The school, which served grades one through seven and later grades one through five, was on the Seaboard Coastline Railroad. The building is now on private property but still standing.

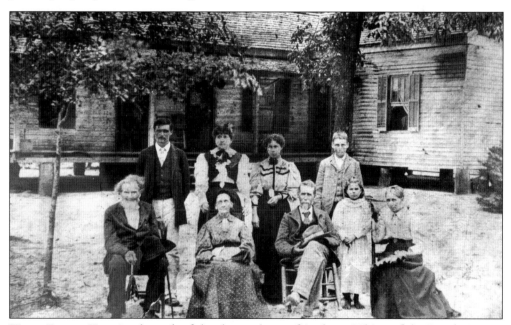

White Family. Here is a branch of the descendants of Anthony White, of the Revolutionary War, at their home near present-day Queen Chapel Road.

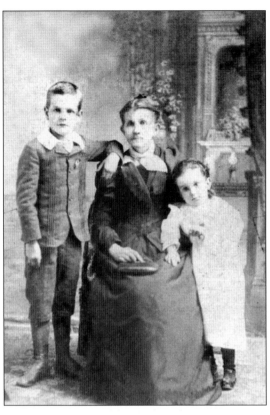

SUSAN WRIGHT CROSSWELL AND GRANDCHILDREN. Prior to 1902, this home was located in Sumter County; however, after 1902 it is in Lee County. Susan Wright Crosswell (1831–1896) was the mother of J. K. Crosswell, who ran a very successful wholesale grocery warehouse in Sumter. When he died in 1929, his will established and endowed the Crosswell Orphanage for orphans of Sumter County.

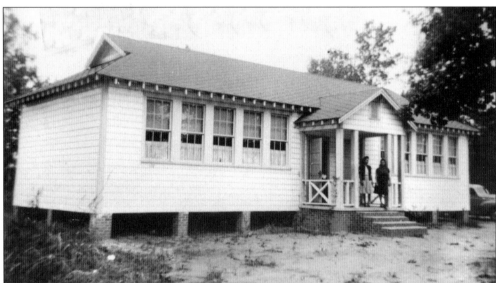

NEBO COLORED SCHOOL, MECHANICSVILLE, SCHOOL DISTRICT #19. The Mechanicsville School District #19 in 1900 had three black private one-teacher schools for 183 students in a 36-day session. The school was located at the intersection of Peach Orchard Road and DuBose Siding Road. Mechanicsville School District #19 became DuBose School District #19 after the formation of Lee County in 1902.

HEBRON PRESBYTERIAN CHURCH. The first services in the community were held in December 1888 in a local schoolhouse at DuBose Crossroads. A sanctuary was built in 1893 on land given by Dr. Henry Y. DuBose. The first pastor was Rev. Charles Malone Richards, who served from 1893 to 1900. The church is the "daughter church" of Hephzibah Presbyterian Church located at Manville in Lee County. The church is located on U.S. 15, six miles south of Manville. Additional facilities and improvements have been added since 1953.

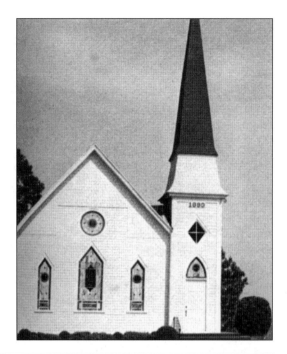

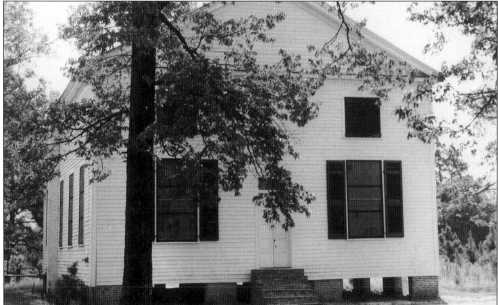

REMBERT METHODIST CHURCH. In the early 1800s Methodist camp meetings were held in tents at locations such as this Rembert site. Later simple, small wooden cottages were used for these five- and six-day meetings. The purpose was to promote religious revivals and inspiration and to convert men into the ministry. Bishop William Capers, of Woodland Plantation, was converted in 1809 as a young man at a camp meeting at Rembert. He gave up the study of law and later became a bishop in the Methodist Church. This church was founded c. 1786, and a chapel was built near Rembert Hall, the home of Capt. James Rembert. The present structure was erected about 1835 and is located about two miles west of DuBose Crossroads.

THOMAS WILSON. Thomas Wilson (1846–1921), a wealthy Clarendon County lumberman, built large sawmills and logging operations in Clarendon County. Wilson became president of the Wilson and Summerton Railroad in 1888 and built rail lines in Clarendon County from St. Paul north to Sumter. In 1899 this railroad was renamed the Northwestern Railroad. A rail line from Sumter to Camden was created in 1900 and opened in 1901. Sumter was the largest town on this line. The line had two sections: a northern one to Camden and a southern one to Summerton. In 1927 it had 6 locomotives, 8 passenger cars, and 26 freight cars. Riders using the freight car on the Northwestern Railroad affectionately called it the "None Worse" Railroad.

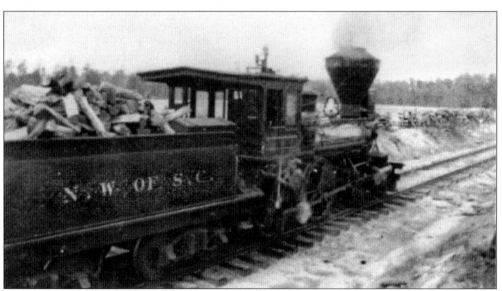

NORTHWESTERN STEAM LOCOMOTIVE, 1904. This wood-burning locomotive was one of the first engines bought by the Northwestern Railroad. The picture above shows the locomotive stopped on the tracks, so this may have been a fuel stop. The firewood would be consumed after 10 to 15 miles of travel. The engineer is shown returning to his cab after he had finished filling the tender car with firewood and possibly water. These engines were soon replaced with coal-burning locomotives.

MT. JOSHUA COLORED SCHOOL, SPRING HILL, DISTRICT #9. Mt. Joshua Baptist Church was organized in 1887 by 25 former slaves, mostly Dees and Jefferson families, who were past members of the white Grant Hill Baptist Church. The school was organized by members of Mt. Joshua Baptist Church shortly after the church was established. In 1900 Spring Hill School District #9 had four black schools with four teachers for 260 students in a session of 48 days. The school was located on Live Oak Road, just west of Peach Orchard Road.

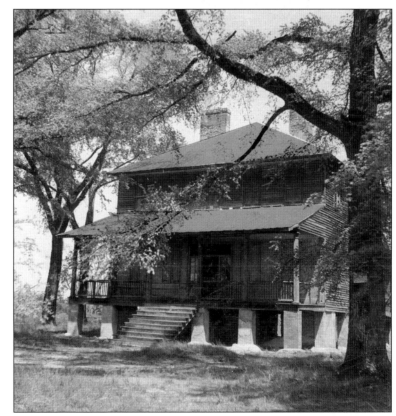

SUMMER HOME OF J. GAILLARD, 1840. This home was built about 1840 at Bradford Springs by James Gaillard, a wealthy planter from Charleston District. He was one of the original vestrymen for St. Philips Episcopal Church, Bradford Springs. The family used it as a summer home to avoid the diseases endemic to the Lowcountry. The house was located near Gaillard Crossroads and no longer exists.

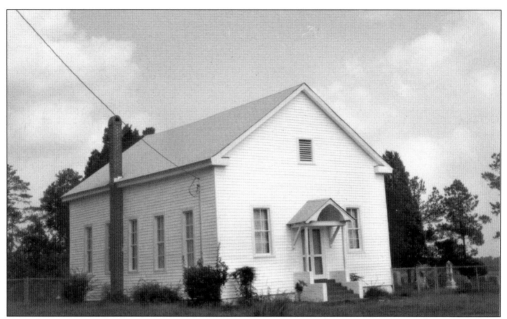

HOREB BAPTIST CHURCH. This church was established in 1889 on land given by Mrs. Eugenia Myers and was a part of the Santee Baptist Circuit. Mr. W. J. Wilder was a trustee. Rev. J. W. Wilder was the pastor in 1912. The church was closed in the 1960s and still stands.

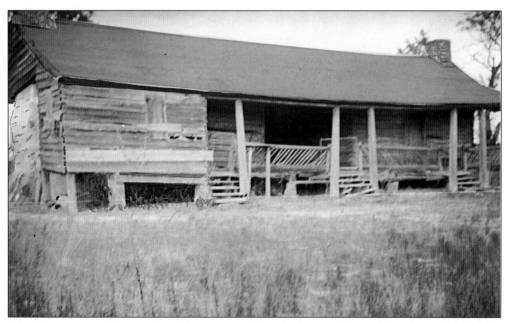

DOG-TROT HOUSE, SPRING HILL. This site was three miles southeast of Rembert and was the homestead of the Cato family. It was bequeathed by Alfred B. Cato to James Nunnery. It was the structure style of early settlers. They cleared the land and built a one-room log cabin. As the farm prospered and the family grew, a second one-room cabin was added with an open-roofed space (dog-trot) in between the two living units. Later an attic was added as sleeping and storage space, and then a back section was built for a kitchen.

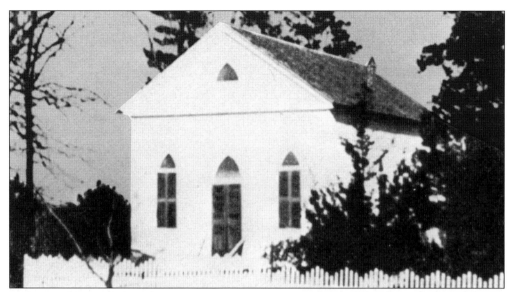

St. Philips Episcopal Church, Bradford Springs. St. Philips Episcopal Church was built in 1840 on three-and-one-half acres donated by Henry Britton on St. Philips Church Road in Bradford Springs. Built in the simple Gothic-Revival style of the finest timber, the church was 42 feet long by 26 feet wide and was dedicated on June 9, 1841, by Bishop Gadsden. Originally a chapel of ease for wealthy Charlestonians summering in the High Hills, regular weekly services began in 1845. At present, a reunion for church families is held annually, with a visiting minister conducting the worship service.

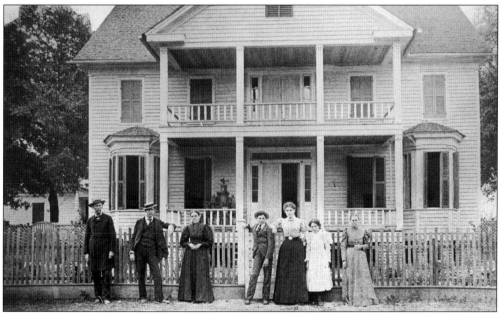

Big House, Providence Springs. This Providence Springs house, built *c.* 1870, was the home of Joshua Judson Myers. Myers moved to this site from the Orangeburg District. The family members are, from left to right, Joshua J., Eugene J., Emily Happoldt, Clarence, Ella, Gertrude, and an unknown person.

91

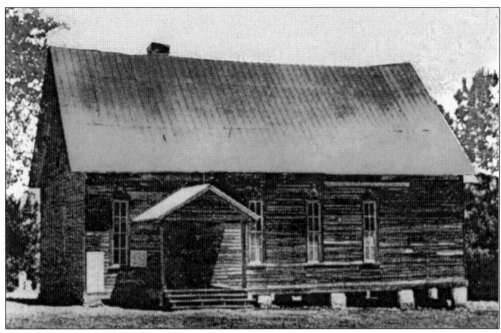

PROVIDENCE SOUTHERN METHODIST CHURCH. The Providence Southern Methodist Church was established in 1785. The initial 1840 building burned in the 1960s and has been replaced by a new sanctuary that stands on this site near Hillcrest High School on U.S. 521.

TIRZAH PRESBYTERIAN CHURCH, DALZELL. Tirzah Presbyterian Church was organized on March 25, 1876. It was named Tirzah for a beautiful woman mentioned in the Old Testament. Tradition says that the sanctuary was fashioned from a barn owned by Johnny Jennings. The congregation has cared for the old white barn, which was remodeled in 1926. They gather for worship on the second and fourth Sundays at 3 p.m. Rev. William Boyd was the first minister, and Rev. N. W. Edwards served from 1877 to 1879.

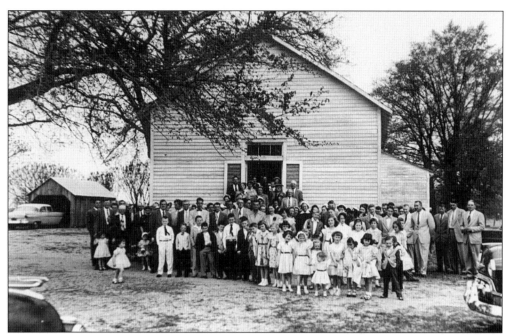

DALZELL BAPTIST CHURCH. The Dalzell Baptist Church was created when some members of the Horeb Baptist Church, three miles from Dalzell, withdrew and created a new Baptist church in Dalzell in 1920. Their pastor was Rev. Cornelius L. Stoney. They met in the schoolhouse until a small frame building with four Sunday school rooms was completed on a one-acre plot initially considered as a site for the Horeb Baptist Church parsonage.

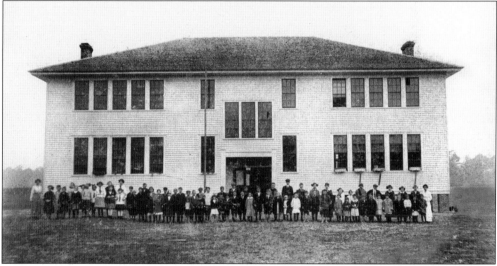

DALZELL SCHOOL, PROVIDENCE DISTRICT #7. This two-story frame building was placed in the new Dalzell School District #7. In 1913 this two-teacher white school had 60 students in a 155-day session. In 1915 Maureen Hammond was the teacher of 68 students. After the May 1923 fire that destroyed the two-story frame Cleveland School in Kershaw County and killed 77 parents and children in the second floor auditorium, school districts locked or removed the second floor in older buildings and only built one-story schools after that.

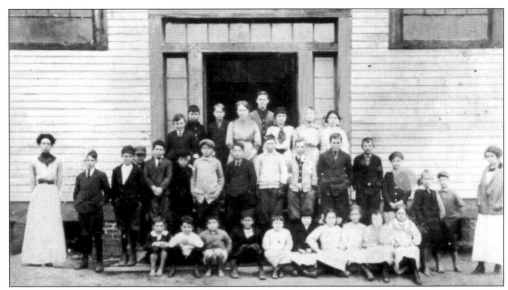

DALZELL STUDENTS, PROVIDENCE SCHOOL, DISTRICT #7. In 1900 Providence School, District #7, had six white public schools with six teachers for 126 students in a 160-day session. The district also had one public and three private black schools with four teachers for 260 students in a session of 48 days. W. S. Smith was the superintendent. The Providence School library was begun in 1905. This building was replaced by the two-story school on the bottom of page 93.

EBENEZER PAROCHIAL SCHOOL (AFRICAN-AMERICAN), PROVIDENCE DISTRICT #7. The Presbyterian Church U.S.A. (north) sent Rev. Jonathan Clarkston Gibbs of Philadelphia to establish church missions. He established Ebenezer Presbyterian Church and Ebenezer Parochial School in the 1867. The schools were organized to educate the children of freed slaves in the Dalzell area. In 1900 Ebenezer Parochial School was in Providence School District #7, which had four one-teacher black schools for 470 students in a 72-day schedule. In 1913 this one-teacher school was in District #9 and had 240 students in an 80-day schedule.

HOG-KILLING TIME. Here is Rebecca Glover at the Weldon House, Providence Springs. The men are cleaning a hog while Rebecca stands at the scalding tub.

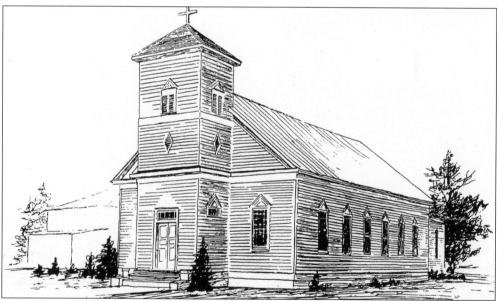

EBENEZER PRESBYTERIAN CHURCH. Ebenezer Church was organized in 1867 due to the efforts of J. J. Knox, an elder in the First Presbyterian Church of Sumter, who gave the land to his ex-slaves for a church and cemetery. He saw the need for a church to minister to the black freedmen in the Dalzell area. He contacted the Presbyterian Church U.S.A. (north), and they sent Rev. J.C. Gibbs, who arrived in Dalzell in 1866. By the spring of 1867, he led 37 charter members to organize the Ebenezer Presbyterian Church. The site is off U.S. 521 North at the intersection of Ebenezer Road and Queen Chapel Road, east of Dalzell.

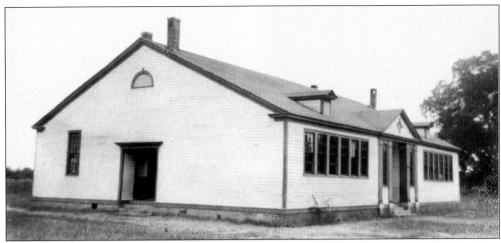

TURKS SCHOOL, PROVIDENCE DISTRICT #7. In 1900 Providence School District #7 had six white and four black one-teacher schools for 183 white and 260 black students in sessions of 72 and 48 days. The Turks made up a third, small but distinct, racial group. They attended their own segregated school and established their own church. Some family names were Benenhaleys, Rays, Oxendines, and Hoods. This one-teacher school, called Benenhaley in 1913, had 28 students in a 138-day session. It was located on the west side of Frierson Road, one mile south of Dalzell.

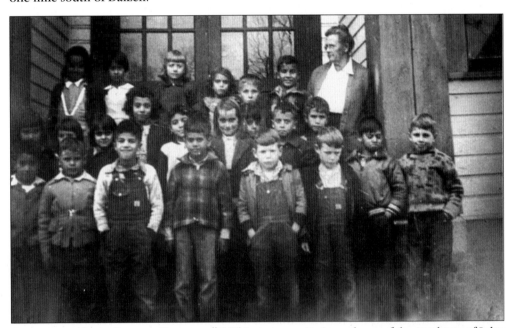

STUDENTS AT TURKS SCHOOL, DISTRICT #7. This community is made up of descendents of John Scott and Joseph Benenhaley, who fought with Gen. Thomas Sumter during the Revolutionary War. General Sumter gave these men some land near his own to honor their service in the war. They may have been of Arab descent. They members of a close-knit society who seldom married outsiders. In 1900 these farmers attended their own school and their own Long Branch Baptist Church. The community is still viable today. Very few have moved away from this community.

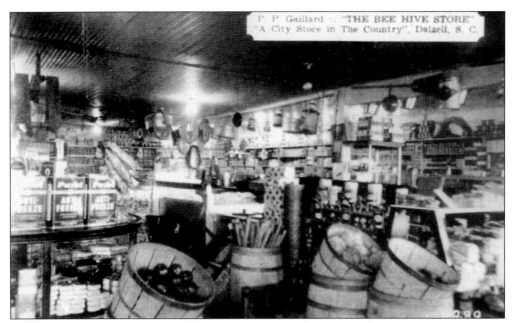

BEE HIVE STORE POSTCARD, *c.* 1935. This store was opened in 1932 and was operated by Phillip P. Gaillard of Dalzell, who was the postmaster. The store was built beside the post office. The initial cost to stock the store was $14. This small family grocery store left the produce and fruits in the initial baskets or boxes. Other products were on shelves behind counters or in glass display cases. The store no longer exists.

LONG BRANCH BAPTIST CHURCH. The Turk racial community initially worshipped at High Hills Baptist Church. Later they created their own church, the Long Branch Baptist Church. In 1904 it had 29 members, and Rev. William Wilder was the minister from 1904 to 1908. The Turk families mainly lived in this small community and avoided dispersal into the general society. Very few moved away from this community.

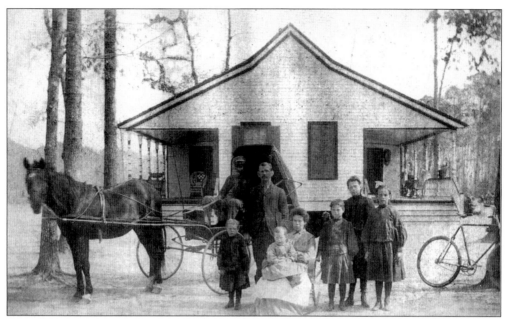

MOORE FAMILY AND HOUSE, 1904. Samuel Francis Moore and Martha Ellen Spicer Moore's family is shown in front of their home that was built *c.* 1900. The daughters, standing from left to right, are Janie (b. 1899), Annie (b. 1896), Edith (b. 1892), and Nellie (b. 1894). Johnsie (b. 1902) is in Martha's lap. Family portraits taken by a traveling photographer almost always includes the significant farm animals and pets.

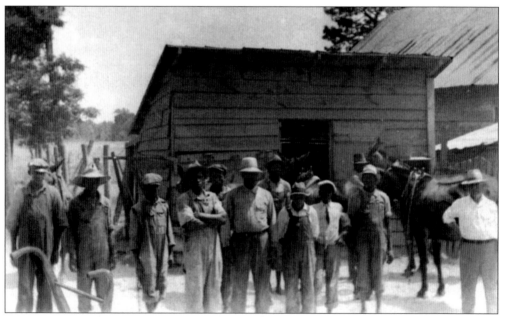

H. CURT EDENS FARM WORKERS, 1936. This 1936 photograph shows H. Curtis Edens Sr., on the right, with his farm workers. It took this work force, plus 16 mules, to operate a 556-acre farm in the Dalzell area of Sumter County. The crops grown on the farm were cotton, corn, oats, and watermelons.

HOBO HOUSE, C. 1930S. Mr. J. R. Moore of Dalzell built a small house beside the highway with a sign reading "Hitch Hiker's Home," where a traveler could spend a night free and obtain breakfast.

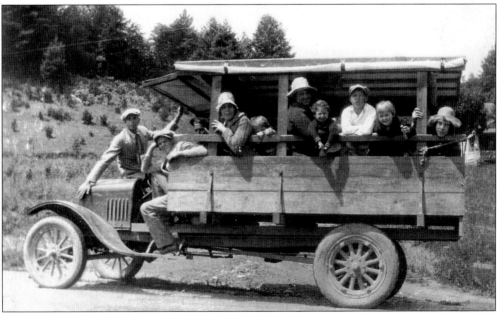

FAMILY OF H. CURTIS EDENS SR., 1930. In the summer of 1930 these members of the family of H. Curtis Edens Sr. are preparing for a trip to Ferguson, North Carolina, a distance of 160 miles from Dalzell. It took 12 hours to make the trip. The vehicle is a Model T Ford truck with a body custom built by Edens.

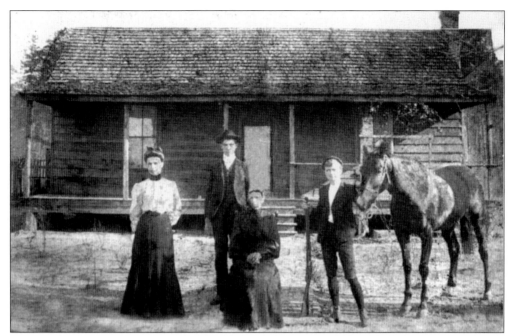

DINKINS FAMILY AND HOUSE. The Dinkins family home was near old Knox Place on U.S. 521 between Sumter and Dalzell. John Scriven Dinkins was the father, and Susan Jones Dinkins was the mother of this family. The above members are, from left to right, Rosa Dinkins (1879–1949), Vernon Robert Dinkins (1887–1961), Susan Jones Dinkins (seated), and Claude Dinkins (1889–1968).

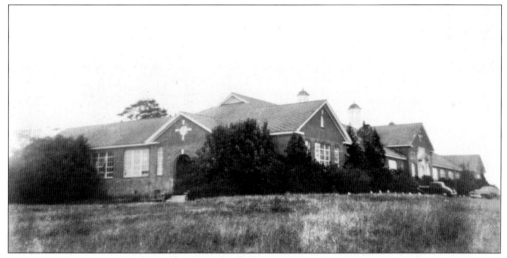

HILLCREST HIGH SCHOOL, DISTRICT #32, c. 1927. Hillcrest High School was built in 1926 to consolidate white grammar schools in the Rembert, Hagood, Stateburg, Dalzell, and Horatio communities. It also housed several elementary grades for a few years. James D. Blanding was the first superintendent. The school was located on the northeast corner of Camden Highway and Peach Orchard Road. Later, a new high school was built on the southwest corner of the same intersection. The original building, pictured here, was sold in 1964 and is now used by Thomas Sumter Academy.

H. CURTIS EDENS JR. This 1932 photograph shows H. Curtis Edens Jr. in front of his home in Dalzell, riding a cart pulled by his pet goat, Billy. The house was built in 1892. Curtis and his wife, Ruth, remodeled the house in 1964.

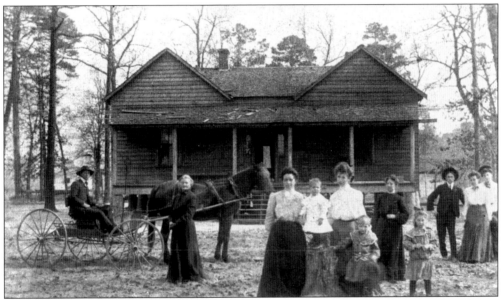

CARSON FAMILY AND COTTAGE, *c.* **1905.** This home was owned by one of Elisha Scott Carson's daughters. The site is near Homefield (see the top of page 25). This family picture was likely taken the same day as the photograph of Homefield. Several family members are wearing the same clothing in both photographs. Family portraits in this era often included their horse or mule, which was a status symbol and their most valuable family possession. This site is near the east side of Shaw Air Force Base.

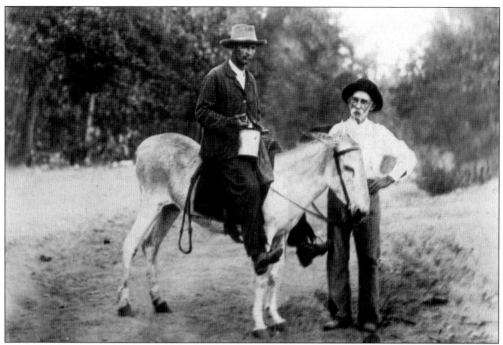

TWO MEN AND A DONKEY. Mr. Colclough (on the donkey) of Orange Grove Plantation and Eli W. Parker, a neighbor, pose for a comic picture. The donkey was the normal means of transportation for tenant farmers. The site is on U.S. 441 near Black River Road in northern Sumter County.

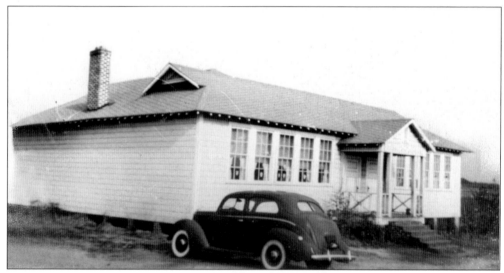

CATCHALL-SPANN COLORED SCHOOL, STATEBURG, DISTRICT #11. The 1900 Stateburg District #11 had seven one-teacher black schools for 549 students in a session of 60 days. In 1913 this one-teacher school had 73 students in a 60-day session. In 1920 the initial building was replaced with a Rosenwald Fund schoolhouse. Rosenwald schools were designed using the latest architectural standards. The building stands on the west side of Peach Orchard Road, just north of Raccoon Road.

CROSSWELL AND HORSE, "DOCK." Bessie Crosswell, a niece of J. K. Crosswell, and her horse, "Dock," are standing in front of her home in the Dalzell community. Children of this era had mules or horses to go to school or run errands for the family.

RAFFIELD FAMILY AND FRIENDS, DALZELL. The Raffield family and friends from the Dalzell community are shown here. They are, from left to right, as follows: (front row) John Benjamin (1851–1914), Rebecca Anna Bryan (1857–1896), Bertha Jennings (on lap, 1891–1909), Walter Herbert (1886–1947), and J. J. Knox (1809–1895); (second row) Sallie Eva Burkett (1881–1950), Susan Augusta (1878–1936), Mary Caroline Michaux (1876–1967), Minnesota Bryan Thompson (1879–1940), and John Benjamin (1880–1954). John Johnson Knox, a plantation owner, gave land for the Ebenezer Presbyterian Church and left land to his former slaves.

ELI W. PARKER, CONFEDERATE STATES OF AMERICA. Eli W. Parker (1837–1924) married Emma Walker of Camden in 1860. They had a family of 16 children; however, three died in infancy. Emma died in 1898, and Eli married Margaret Stroud of Chester in 1899. Parker, who saw service during the Civil War, moved to the Dalzell community in 1898 and became a prominent farmer in the area. Eli was a member of the Dalzell Baptist Church.

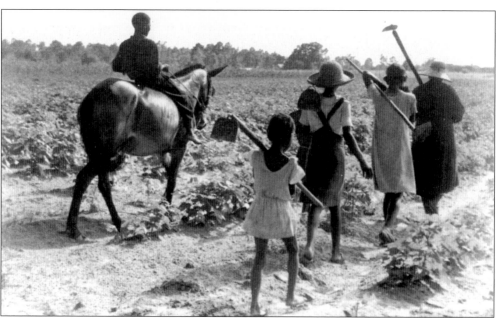

HOEING COTTON. Cotton was the major cash crop of Sumter County for nearly 200 years. Before the days of mechanical equipment, all the work had to be done by hand, from seeding to picking. "Gangs" of slaves did the work at one time; later, it was done by sharecroppers and small farm families. Here a family sets off to chop cotton, i.e., eliminate the weeds.

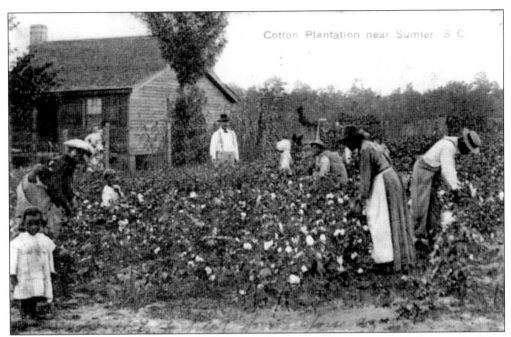

COTTON PLANTATION POSTCARD, C. 1910. This generic cotton-picking scene is typical of this era. After slavery was abolished, the planters shifted to sharecropping to plant, care for, and harvest the cotton crop. Sharecroppers usually lived in cabins owned by the landowner. Checks were often given for a week's worth of service, and these could be cashed in the farm's commissary or at a local general store.

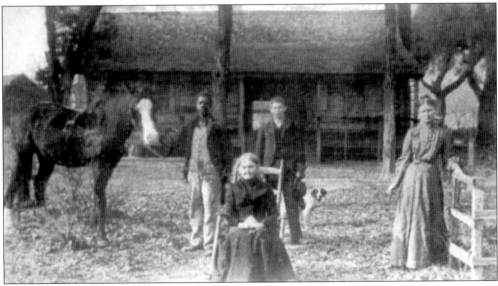

RAFFIELD FAMILY, WOLFPIT HOUSE. The Raffield family, shown above, has Mrs. S. C. Raffield (seated), Ms. Sue (standing), Nat Lewis (with horse), and Frank Raffield (standing behind the chair). Sue operated the "Sibley" Post Office at this site in the early 1900s. This site was a stop on the old Northwestern Railroad known as Sibley Siding. This site was one mile north of the present-day U.S. #76/378 bypass on U.S. 521.

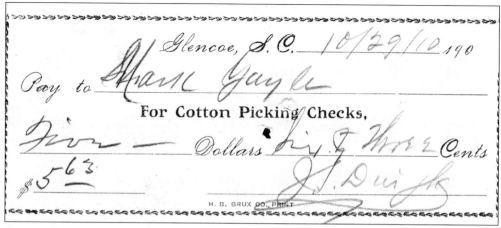

COTTON-PICKING CHECK. This 1910 check shows the amount that a family was paid for a week's work of picking cotton on a Sumter farm. The family often consisted of a man, wife, and children. It could be cashed at the farm's commissary that carried all the normal food, clothing, and general merchandise.

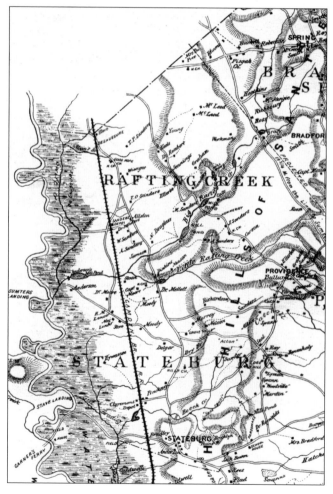

MAP, RAFTING CREEK SECTION, SUMTER COUNTY, 1878. The northwestern corner of Sumter County shows the northern end of the High Hills of the Santee where it abuts Kershaw County. The upper portion of the Wateree Swamp and related creeks are shown. The 1848 railroad right-of-way with the depot towns are noted. Towns, roads, houses, and even the Lenoir Store in Horatio are marked.

Five

RAFTING CREEK TOWNSHIP

This area is located at the northern end of the High Hills of the Santee. Following the Revolutionary War, wealthy Charleston planters and merchants built summer homes in the Bradford Springs area.

With the introduction of the cultivation of cotton, these homes became large cotton plantations. In 1848 the Camden Branch was opened, providing a rail link to Charleston and Columbia. The towns of Claremont, Horatio, and Hagood developed along the railroad.

After the Civil War, freed slaves established their own churches and opened schools for their children. In 1900 the Northwestern Railroad of South Carolina built a line directly from Sumter to Camden. Post offices opened, business boomed, and the towns grew. As the automobile became more popular, paved roads replaced the railroad and slowed the growth of the small towns. Crop failures and the Depression of the 1930s caused the area to revert to a mosaic of large plantations and small farms.

McLeod's Chapel Methodist Church, Rembert. Originally organized *c.* 1879 as St. Matthew's Church with 32 members, the congregation met in a local schoolhouse for 12 years. Land was given for a church in 1884. On the first Sunday in October 1897, the church was formally dedicated and the name changed to McLeod's Chapel Methodist Church. The building has received significant renovations since 1949.

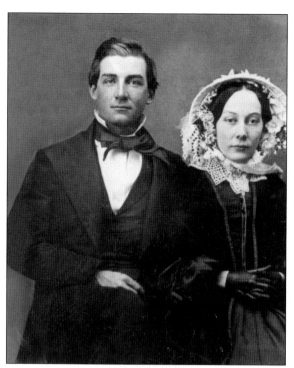

WILLIAM AND MARY SANDERS ELLERBE. William Crawford Sanders Ellerbe (1829–1895) and Mary Eunice Sanders (1832–1895) married in 1853. This is their wedding photograph. They moved to Camden in 1865. In 1890 they built a house on the millpond and moved back to Millvale Plantation. The plantation consisted of the mill, a store, and a large tract of land on Rafting Creek in the Hagood section. They organized the effort to raise funds to build the (Episcopal) Church of the Ascension, Hagood, that was completed a year after their deaths in 1895.

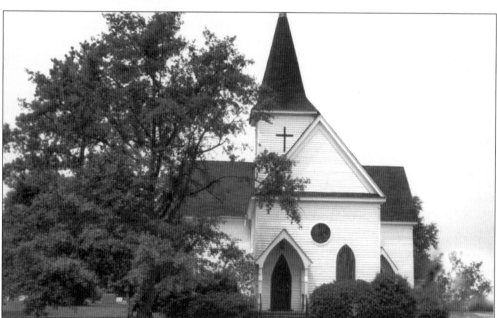

CHURCH OF THE ASCENSION. The (Episcopal) Church of the Ascension became an organized parish on June 30, 1895. Rev. James Stoney gave the first sermon. The building, built entirely of pine cut from the land of William C. S. Ellerbe, was consecrated on March 8, 1896. It rests on land purchased from William Sanders in 1807 for use as a cemetery by the Shiloh Burying Association. The name Ascension was thought appropriate since the site had long been used as a cemetery. The first regular minister was Rev. William H. Barnwell.

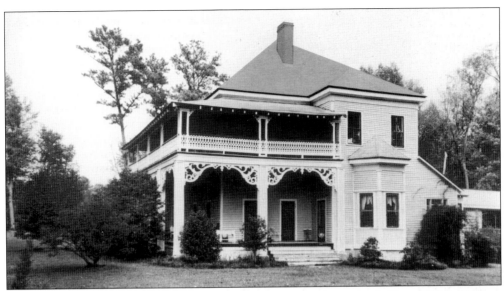

MILLVALE PLANTATION HOUSE, REMBERT. Millvale Plantation House was built *c.* 1890 by William and Mary Ellerbe on the millpond at Millvale Plantation so that he could live closer to his work. It was built in the Victorian style by their son, Napoleon G. Ellerbe. In addition to the house, the plantation consists of the mill, a store, and about 1,500 acres that was originally granted by George III to the Sanders family in the mid-1700s and later sold to William Sanders Ellerbe. Millvale was the only self-sustaining plantation still operating in Sumter County in 1975.

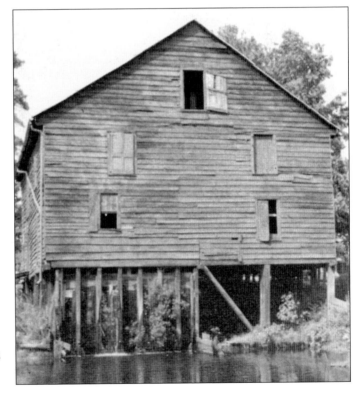

ELLERBE'S MILL, 1830. This mill was built in 1830 by George Sanders and sold to William Crawford Sanders Ellerbe in 1860, at the time that Ellerbe was assembling Millvale Plantation. It is located on Big Rafting Creek, about two miles south of Rembert. Legend has it that the mill was spared by General Potter in 1865 because Dr. William Ellerbe's Masonic apron was hung over the entrance to the mill. The mill is supported by hand-hewn beams. It has not been altered since its construction. The mill was grinding meal in 1975 and still stands today.

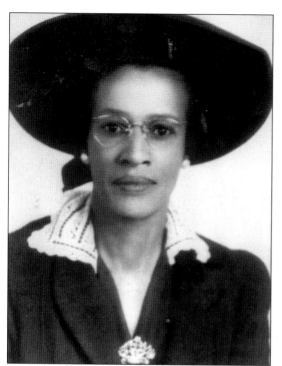

DR. MAE MARION WOODARD WRIGHT. Dr. Mae Woodard (1895–1994) was born in Eastover. In 1919 she married Thomas B. Wright, a prominent businessman and farmer in the Hagood area. After his death in 1925, she married Rev. Leslie McLester and continued to run the farm, operate the cotton gin and sawmill, and rear and educate her five children. She helped secure Rosenwald Funds to rebuild the Rafting Creek Colored School, donated the property on which the school was built, and borrowed money to provide the required local funding. She taught there and became its principal. She was a devoted and generous member of Rafting Creek Baptist Church. "Miss Mae" received numerous honors, awards, and citations for her lifelong contributions to her community. (Courtesy of her daughter, Margaret Wright Davis.)

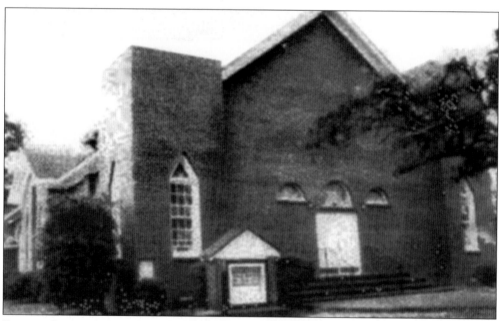

RAFTING CREEK (AFRICAN-AMERICAN) BAPTIST CHURCH. This church was organized in 1871 with 25 members by Rev. Theodore Diggs (1871–1923). They built a small church on Big Rafting Creek on land purchased from William Ellerbe in 1874. The initial structure was replaced in 1890. It was destroyed by a flood in 1925 and rebuilt in 1930. During this period Rev. Leslie McLester was the pastor. The present structure was built in 1952. The church congregation numbers over 700 in 2005.

THOMAS BOSTON WRIGHT.
Thomas Boston "T. B." Wright (1877–1925), eldest son of James and Agnes Wright, was born in the Rafting Creek area. After attending Benedict College, his father gave him a mule and a plow to make his start in life. Thomas married Caroline Mayrant in 1898, and they adopted two children. After Caroline's death, Thomas married Mae Woodard in 1919. He became a successful Hagood businessman, property owner, and farmer who owned and operated a cotton gin, sawmill, syrup maker, country store, and community hall. He was devoted to Rafting Creek Baptist Church, its school, and the community. (Courtesy of his daughter, Margaret Wright Davis.)

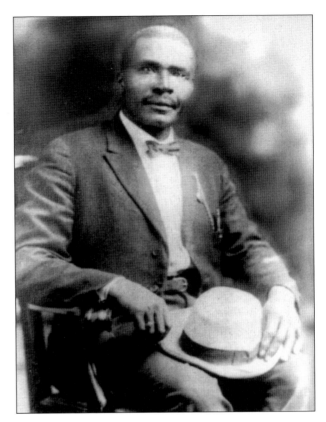

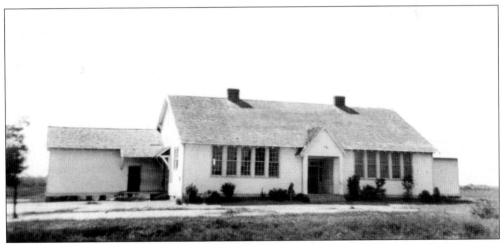

RAFTING CREEK COLORED SCHOOL, RAFTING CREEK, DISTRICT #8. Rafting Creek School was started by the congregation of Rafting Creek Baptist Church prior to 1900. In 1900 District #8 black division had one public school and three private one-teacher schools with four teachers instructing 370 students in an 80-day session. The original building was replaced by a Rosenwald school *c.* 1927. When that building burned in 1943, Principal Mae (Wright) McLester personally petitioned President Roosevelt for funds to rebuild the school. The school has been renovated several times and is still in use.

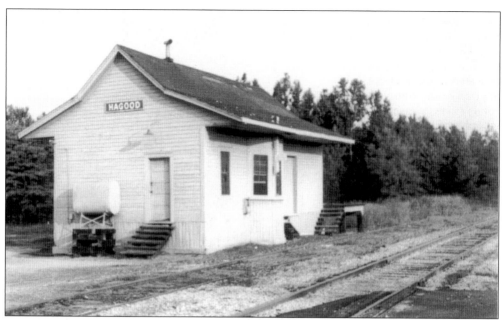

HAGOOD DEPOT. Originally named Sanders Depot on the Camden Line, it was built in 1848. Later, the name of the depot was changed to honor Gov. Johnson Hagood. Camden Line became part of the Southern Railway Company in 1902. The depot has always been used to ship local products to Charleston and other cities. As late as the 1960s, sand and gravel were shipped from Hagood to Calhoun and Orangeburg Counties. The depot has been torn down. In 1910 Hagood's population was 215. (In 1913 Hagood's one-teacher school had 15 white students in a session of 149 days; the black system one-teacher school had 67 students in a 59-day session.)

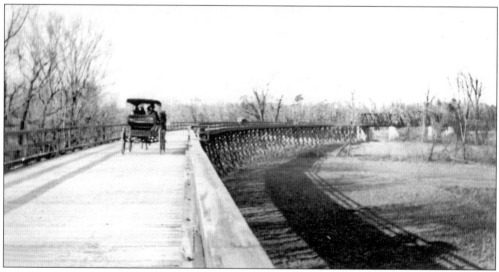

CAMDEN ROAD. To create a roadway through swampy areas, a series of wooden supports were built to carry the road above the normal water level. Wooden planks provided the roadway itself. When the rivers flooded, many of these roadways would be washed away. Note the bridge itself in the right center of the photograph.

CON. GEORGE WASHINGTON MURRAY. Born of slave parents near Rembert in 1853, George Washington Murray was educated in local schools and the University of South Carolina. For 15 years he farmed, taught school, and bought land that he subdivided and sold on easy terms. In 1890 he was appointed as an inspector of customs in Charleston. In 1892 he was elected to Congress as a Republican with the help of Gov. Ben Tillman. Unable to run again under the South Carolina Constitution of 1895, he served in Congress until March 1897. According to H. G. Osteen, editor of the *Watchman and Southron*, "He became the largest landowner in Sumter County." He went to Chicago in 1905, where he died in 1926. (Courtesy of Sumter County African American Cultural Society.)

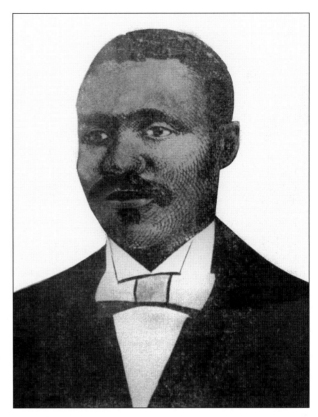

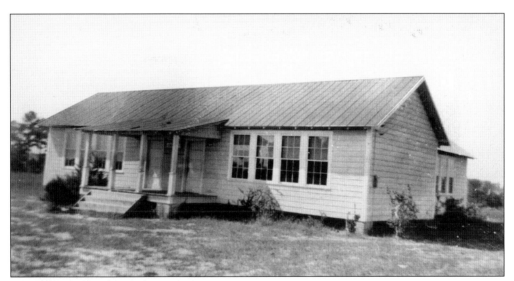

REMBERT MEMORIAL COLORED SCHOOL, RAFTING CREEK, DISTRICT #8. Rembert Memorial School was located at the corner of Frye Road and Young Street in Rembert. In 1900 District #8 black division had four one-teacher schools with 370 student in an 80-day session. This photo is of a more recent building. The school is no longer being used. The population of Rembert was 200 in 1910.

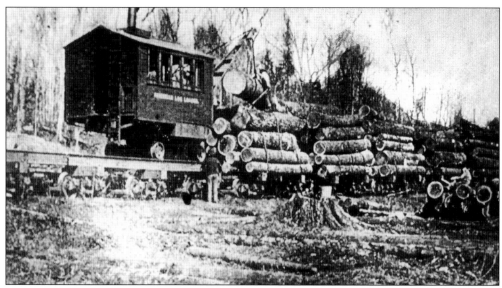

DECKER STEAM LOADER. The Decker Steam Loader could roll along a track that was placed on the top of a line of flatcars. It lifted individual logs and placed them on the first flatcar, and then backed up to load the second car and each succeeding flatcar. When the string of flatcars was fully loaded, a steam engine would pull them to the sawmill. Logging was a major activity in the forest along the Wateree River.

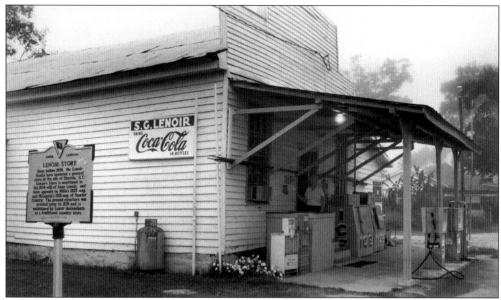

LENOIR STORE, HORATIO. The Lenoir family has operated a general store in Horatio since before 1808, when the store was mentioned in the will of Isaac Lenoir. The store has passed through six generations of the Lenoir family. The present structure was erected prior to 1878 and is marked on the 1878 map. A post office has been located in the store since before 1900. Often the owner qualified and was appointed postmaster. The store continues to stock products in the same old-fashioned way that our grandparents enjoyed. The store is located on Sumter Landing Road. In 1910 the population of Horatio was 50.

Six

PALMETTO PIGEON PLANT

The Palmetto Pigeon Plant was started in 1923 by two of Sumter's bright young men. Wendell Mitchell Levi had raised pigeons as a youth and had served with the Pigeon Section of the United States Army Signal Corps during World War I. His partner, Harold Moise, had earned his Pilot Wings with the United States Army Air Corps in 1918 and then returned to Georgia Tech to earn a bachelor of science degree in mechanical engineering.

The two began with 40 breeding pairs of pigeons, and after two years their flock numbered almost 300 breeding pairs. By 1925 the plant had produced 3,174 squabs (a 28-to-30-day-old pigeon prepared for market). The plant became the largest producer of squabs in the United States. Levi wrote many papers on the care and breeding of pigeons. He served as president of the National Pigeon Association. The plant is still in operation today.

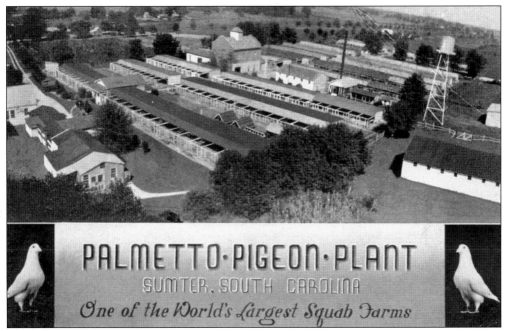

PALMETTO PIGEON PLANT. This advertising postcard was used to correspond with individuals and companies, to make public announcements, and to answer simple questions. The card is an aerial view of the plant. Since the pigeon plant was initially outside of the city limits, Moise had to lay a water line to the plant's hand pump.

TROPHIES WON. This 1928 picture shows the trophies and ribbons won by the Palmetto Pigeon Plant in the years prior to 1928. Their pigeons were entered in agricultural fairs at the county, state, and regional levels, including the Charleston Agricultural and Industrial Fair, the Georgia State Fair, and the Tri-State Fair in Memphis, Tennessee. The plant was considered to be one of the best in the United States.

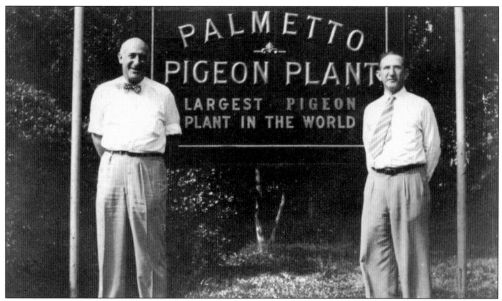

OWNERS OF PIGEON PLANT. Two of the owners, Harold Moise and Wendell Levi, of the Palmetto Pigeon Plant are standing in front of their sign at the entrance to their Sumter site. The young squabs are sold to individual restaurants and to resorts like The Cloisters in Georgia and Homestead and Greenbrier in West Virginia. They have also been sold directly to families such as DuPonts, Rockefellers, Roosevelts, and others.

116

PRIZE-WINNING PIGEON. The pedigreed White Carneau pigeon is the primary pigeon raised at the plant. Other breeds include White King, Silver King, French, and Swiss Mondain. The cock chooses one hen and stays with her. The average number of birds raised from a pair is 12.

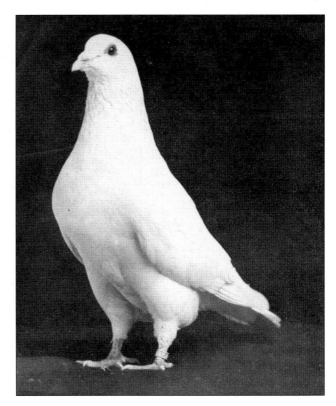

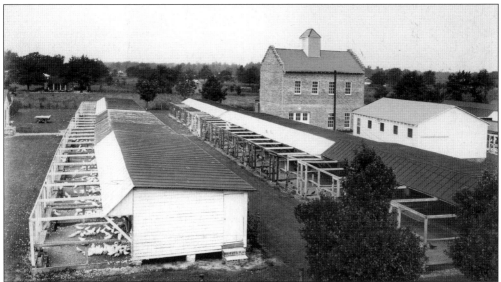

VIEW OF BIRD HOUSES. This view shows the pigeon coops on the left side of the picture. Each mated pair has two nests, one for hatching eggs and one for growing squabs. Each hen usually lays two eggs and then sits. Within 18 days the birds hatch. Both the cock and the hen share in the care and feeding of the young. The two-story grain storage building at the back stores 180 tons of grain that includes corn, sorghum, peas, and wheat. Five thousand pounds of food is consumed daily by the 32,000 birds.

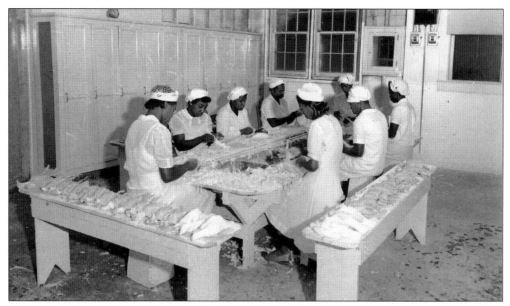

PLUCKING FEATHERS OFF THE PIGEONS. The young squabs are ready for market in 28 days. They weigh from 12 to 14 ounces when dressed. They are graded by weight and then stored in a freezer. The ladies with hairnets are seated at a worktable plucking the feathers off each bird and then placing the dressed squabs on a bench behind them. In the 1960s, dressed squabs sold for between $1.50 and $1.85, depending on weight. Over 1,000 birds were dressed in a day.

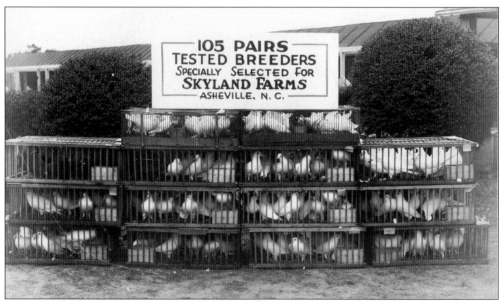

BREEDING PIGEONS SHIPMENT. In the past, breeding pigeons were sold to other farms. This picture shows a shipment from the Sumter plant to Skyland Farms in Asheville, North Carolina, to start a pigeon plant there. After five years of breeding, the hen and cock have exhausted their usefulness. The older pigeons are often sold to research laboratories like those at MIT, Harvard, and Yale.

Seven

SHAW AIR FORCE BASE

In the fall of 1940, Sumter leaders offered to provide land for a pilot training base near the city of Sumter. After making an on-site inspection, the secretary of war approved a site eight miles northwest of Sumter in May 1941. Runway construction commenced immediately. The first aircraft landed on October 22, 1941. The first basic pilot training class arrived in December 1941 and graduated on February 19, 1942.

In April 1951 the 363rd Tactical Reconnaissance Wing was assigned to Shaw with RF-80 and RB-26 aircraft. During the ensuing 30 years, each generation of tactical reconnaissance aircraft were assigned first to Shaw. Crews were trained at Shaw and assigned world wide to meet the needs of the tactical reconnaissance mission. For the past 60 years, Shaw has been an integral part of Sumter County and the City of Sumter.

LT. ERVIN D. SHAW, ARMY AIR CORPS. This pilot was killed over France on June 9, 1918, while conducting a reconnaissance mission over German lines. A native of Alcolu in Clarendon County, Shaw trained in Savannah, Georgia, and Mineola, Long Island. Commissioned in the Canadian Air Force, he was serving with the Royal Air Forces' 48th Squadron when he was killed. He was nicknamed "Molly" because as a child he used the phrase "hot tamale" as exclamation.

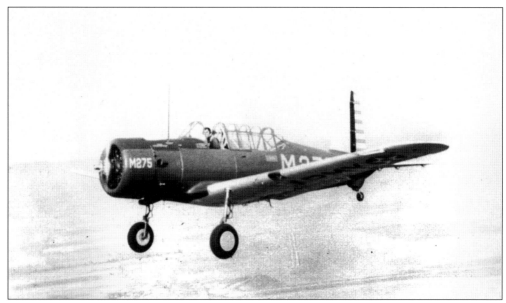

BT-13A, First Aircraft Flown at Shaw Field, 1942. Shaw Field was officially activated August 30, 1941. Runway construction was completed in September. The BT-13A, a single-engine two-place trainer, was used to train pilots in a nine-week course. During 1942, 2,600 pilots were trained at Shaw Field. The fleet of aircraft increased from the initial cadre of 56 in 1941 to 218 in 1942. Shown here is a student pilot on a solo mission.

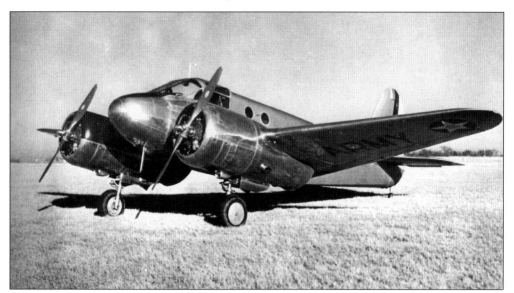

AT-10 Multi-engine Trainer, 1944. In 1943 the training program was increased to 10 weeks. To enhance the capabilities of pilots graduating from basic training in instrument and night flying, the Beechcraft AT-10 was assigned to Shaw Field in 1943. Built of plywood except for the engine cowlings and cockpit enclosure, the AT-10 proved to be a reliable trainer. By the end of 1944, some student pilots trained using only the AT-10. In 1944 the AT-6 replaced the remaining BT-13s for the single-engine phase of training. In May 1945 the last basic flying class graduated. Shaw Field trained 8,600 pilots between 1942 and 1945.

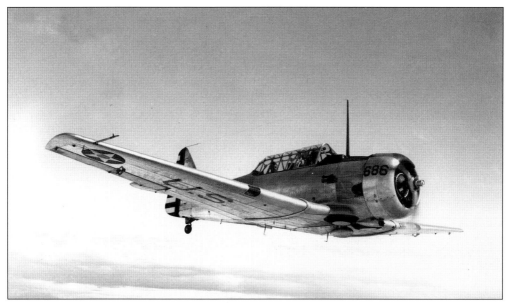

AT-6 Single-engine Trainer. This high-powered Advanced Trainer arrived at Shaw in September 1944. The AT-6 replaced the last of the BT-13s. In April 1945 the AT-6s and AT-10s were replaced by P-47s. On April 18, 1945, Shaw welcomed its first class in basic transition flying for fighter pilots selected for overseas duty.

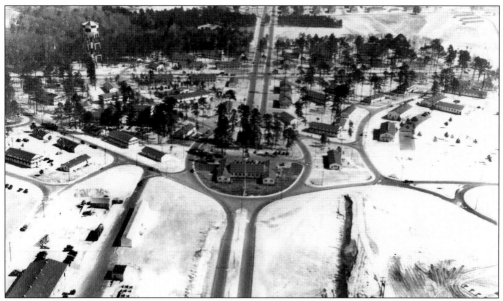

Aerial View, Shaw Field Headquarters, 1946. This photograph shows how Shaw Field looked in 1946. The base had been assigned to Tactical Air Command in March 1946, and the 20th Fighter Wing arrived with three squadrons of P-51s that October. The industrial area is to the left, base exchange and support buildings to the right center, barracks to the middle left, and training facilities in the far distance. The flight line was to the right, off the photograph.

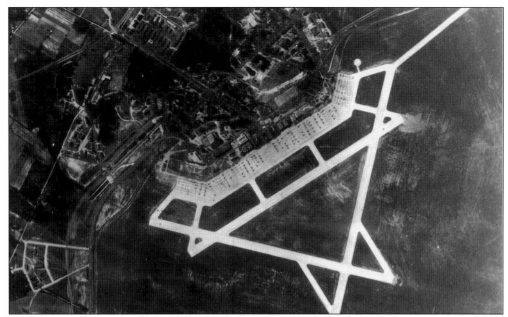

AERIAL VIEW OF RUNWAY LAYOUT, SHAW FIELD, 1946. The triangular pattern of runways was typical of all early airfields, since take off and landing needed to be made into the wind. With this pattern, flight operations could continue regardless of the wind direction. Initially the runways were about 5,000 feet in length. The runway parallel with the ramp area was extended to 10,000 feet, and a second parallel runway was completed in 1974. On the ramp are P-51s, B-26s, AT-6s, and P-47s.

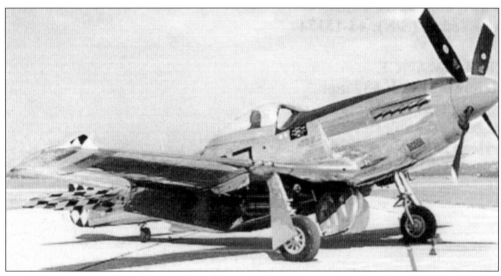

NORTH AMERICAN P-51D. The 20th Fighter-Bomber Group arrived in the fall of 1946. The unit was equipped with the P-51D and the F-6, a photo-reconnaissance version of the P-51. During World War II the primary mission of the P-51 was to escort bombers on long-range missions. It also had the capability to support army ground units engaged in combat. The main runway at Shaw was extended to 10,000 feet as the 20th Group prepared to accept the F-84 aircraft.

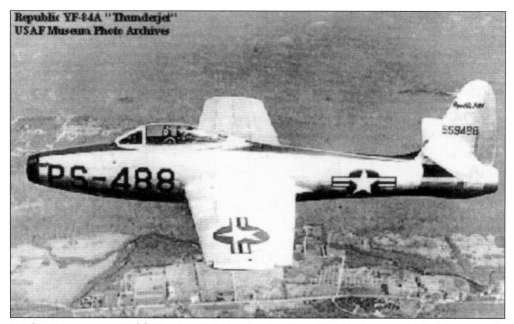

F-84A, THUNDERJET, 1946. The first F-84s arrived at Shaw Field in January 1948. This aircraft, designed for low-level interdiction missions, achieved its greatest renown during the Korean Conflict. With a one-man crew, it could carry six .50-caliber machine guns and eight five-inch rockets or 2,000 pounds of bombs or napalm. The 20th spent the fall of 1950 in England and was transferred, permanent change of station, in 1952. Shaw Field was designated Shaw Air Force Base on January 13, 1948.

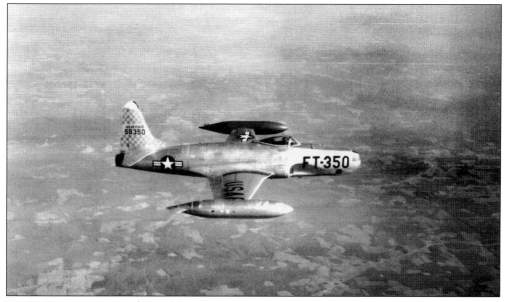

RF-80 ASSIGNED TO THE 432ND TACTICAL RECONNAISSANCE GROUP (TRG). The 432nd TRG was organized on March 18, 1954, with two squadrons flying the RF-80 photo-jet planes, while the other two flew the RB-26. The 363rd TRG remained the host unit. It was re-equipped with the RB-57A in March 1954 and the RF-84F Thunderflash in September 1954.

RB-57A "CANBERRA." The distinctive red-and-white checkerboard tail design denotes the 363 TRG. This RB-57A was on display for the May 1954 Armed Forces Day celebration. The aircraft was painted black to fit its night reconnaissance mission. The crew consisted of a pilot and a navigator. The 363rd TRG was the only Air Force Canberra reconnaissance unit stationed in the United States. All the other units were stationed overseas.

DOUGLAS RB-66C "DESTROYER." In 1956 the 16th TRS and 9th TRS were equipped with the RB-66C. Originally designed as an attack bomber, the B-66 was modified to perform the tactical reconnaissance mission. In 1957 the United States Air Force Advance Flying Training School, Tactical Reconnaissance, was opened at Shaw. As the RB-66C evolved from photo reconnaissance to weather reconnaissance and electronic reconnaissance to electronic jamming, this school evolved to provide training for pilots, navigators, and electronic warfare officers to operate these and the other tactical reconnaissance aircraft assigned to Shaw. Shaw became the home of tactical reconnaissance. The last EB-66C was retired in 1974.

McDonnell RF-101A, "Voodoo." On May 16, 1957 the 17th Tactical Reconnaissance Squadron accepted delivery of the RF-101A. With the delivery of this aircraft, Tactical Air Command and Air Force operational units were able to routinely carry out supersonic photo reconnaissance. On November 27, 1957, four RF-101A from Shaw lifted off from Ontario County Airport, California, and headed east in Operation Sun Run. Three hours and seven minutes later Capt. Robert Sweet flashed across the finish line at Floyd Bennett Field, Long Island, with a new transcontinental speed record.

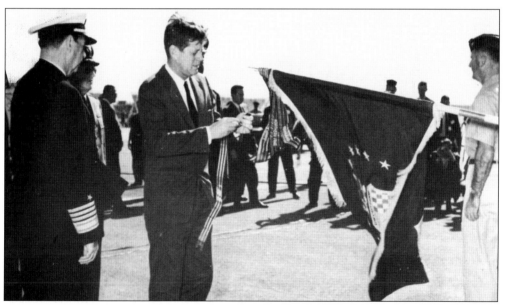

President Kennedy Presents the Air Force Outstanding Unit Award. On November 26, 1962, President John F. Kennedy presented the Air Force Outstanding Unit Award to the 363rd TRW in recognition of the contributions of the pilots of the wing who flew low altitude reconnaissance mission in the RF-101A over Cuba. The photos they provided were proof of the military and missile build up by Russia. Wing aircraft also monitored the removal of the missiles by ship. On September 13, 1963, the Air Force Association presented its highest award, the H. H. Arnold Trophy, jointly to the 363rd TRW and the 4080th Strategic Wing (U-2) for their military reconnaissance efforts over Cuba in October 1962.

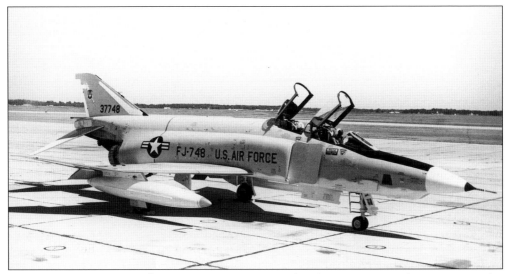

McDonnell Douglas RF-4C, "Phantom II." The RF-4C Phantom II was a long-range, multi-sensor aircraft capable of all-weather day-and-night reconnaissance in high- or low-threat environments. Optical and infrared cameras, side-looking radar, and electronic reconnaissance systems made it the most versatile reconnaissance aircraft in the world. First assigned to the 16th TRS in 1965, the last RF-4C departed Shaw when the 16th TRS was inactivated on December 15, 1989. During the Vietnam War and the Cold War, thousands of RF-4C crew members were trained at Shaw.

ACKNOWLEDGMENTS

We wish to thank the following individuals: Dorothy Reynolds, "Jay" Ingersoll, Louise Dabbs Bevan, Shirley Cockerill, Mr. H. Curtis Edens, Richard P. Evans, Dr. D. Earle Goodman, Henry and Mary Griffin Jr., Ernestine Killinger, Emily C. Kolb, Mrs. Carrie Lenoir, Buford Mabry, Elizabeth Boykin Leavell McCarrell, Brig. Gen. Hugh M. McLaurin, Lillie Nelson, Bill Rhodes, Public Affairs Office, Shaw AFB, William Sanders, Janet Sublette, Harvey Tiller, Caleen S. Watts, and Sally Nash Wilson Sr.

We would also like to thank the South Caroliniana Library, University of South Carolina, as well as the Sumter County Genealogical Research Center.

Publications that proved helpful include *Annual Report of the State Superintendent of Education, 1900–1950; Atlas of Historical County Boundaries, South Carolina* by G. DenBoer & K. F. Thorne; *Stateburg and its People* by T. S. Sumter; *Mysterious Carolina Bays* by Henry Savage Jr.; *50th Anniversary, Shaw Air Force Base, South Carolina; History of Mayesville, South Carolina* by Ethel Cooper Turner, 1983; *Palmetto Pigeon Plant* by R. E. Hanna; *The World's Largest Pigeon Plant* by Jan Wonbrey; *Historic Spots in Sumter County Recommended for Permanent Markers; Logging Railroads of South Carolina* by Thomas Fetters; *History of Sumter County* by Anne King Gregorie; *Historical Sketches of Sumter County: Its Birth and Growth* and *Volume II* by Cassie Nicholes; *Biography of the Blanding and McFaddin Families; Mt. Sinai A.M.E. Church,* by Rev. Davie Brown; *History of Rafting Creek Baptist Church* by Shiloh United Methodist; *St. John United Methodist Church,* Rev. J. R. Cannion; *Salem, Black River,* James McBride Dabbs; and *A History of Bethel.*

The following churches warrant special thanks for their help: Mayesville Baptist Church, The Church of the Holy Cross, Ebenezer Presbyterian Church, and Tirzah Presbyterian Church.

INDEX